IMAGES
of America

LOUISA
AND
LOUISA
COUNTY

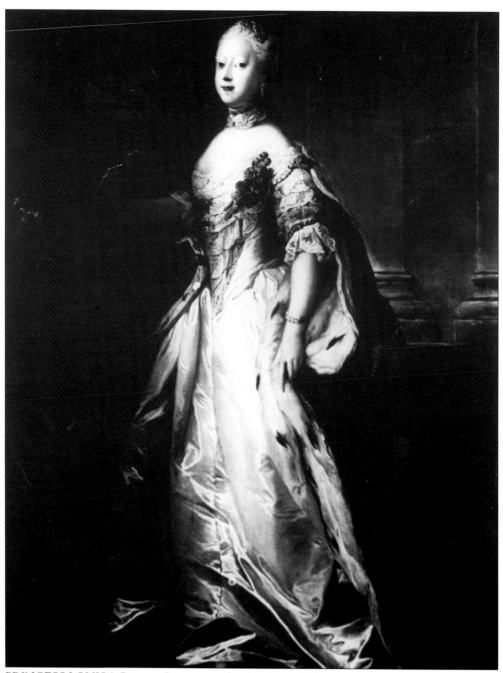

PRINCESS LOUISA Princess Louisa was the daughter of King George II and Queen Caroline. In 1742, when Hanover County was divided, the newly created county was called Louisa County in her honor. On December 11, 1743, she married Crown Prince Frederick of Denmark and Norway. (LCHS)

IMAGES
of America

LOUISA
AND
LOUISA
COUNTY

Pattie Gordon Pavlansky Cooke

ARCADIA
PUBLISHING

Published by Arcadia Publishing,
Charleston SC, Chicago IL, Portsmouth NH, San Francisco CA

Printed in the United States of America

Library of Congress Catalog Card Number: 2006934010

For all general information contact Arcadia Publishing at:
Telephone 843-853-2070
Fax 843-853-0044
E-mail sales@arcadiapublishing.com
For customer service and orders:
Toll-Free 1-888-313-2665

Visit us on the Internet at www.arcadiapublishing.com

Dedicated to the memory of
Porter Wright

Key to Photograph Credits:
Louisa County Historical Society Museum—LCHS
Office of the Clerk of the Louisa County Circuit Court—Clerk
Griswold Boxley—Boxley
The Central Virginian—CV
The John Gilmer Family—Gilmer
William Kiblinger—Kib
Frances Marshall—Marshall
The Talley Family—Talley
Chris Thomasson—Thomasson

COVER PHOTOGRAPH In May 1890 a suit was brought by Editha Pottie *et al* against Eliza Thompson *et al* and the Sulphur Mines Co. of Virginia. The suit concerned a 25-acre tract of mining land near Tolersville. The Pottie Case lasted eight years, with the final decree on March 22, 1898. Some of the gentlemen involved posed for a photograph in front of the east wing of the old courthouse. A few of the gentlemen can be identified. They are, from left to right: (front) Judge George L. Christian, Hill Carter, and Captain Frank V. Winston; (back) I.T. Werner, Z. Parker Richardson, Henry Moncure, Major Andrew J. Richardson, and Clerk Jesse J. Porter (second, fifth, sixth, seventh, and eleventh from the left respectively). To the far left can be seen a corner of the old clerk's office, which was separate from the courthouse. (LCHS)

Contents

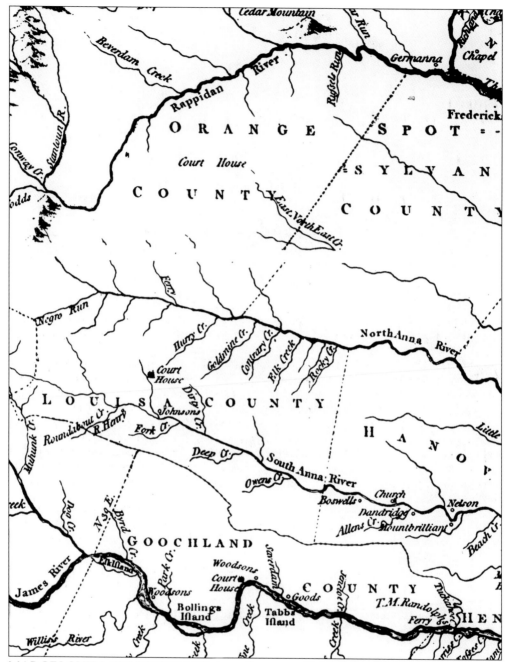

MAP OF LOUISA COUNTY IN 1770 A small section of John Henry's 1770 map shows Louisa County. It delineates the county lines and identifies the courthouse. The only family listed is the Johnson family, which held a great deal of power in Louisa County at the time. (LCHS)

6

Introduction

By 1700 the elk, wolves, bear, and even the last of the Indians (Monasiccapanoe/ Monacan) had left what was to become Louisa County, opening it up for settlement. The Louisa County area (then Hanover County) was colonized and settled relatively late simply because the landlocked Piedmont area of Virginia was difficult to reach.

The county was created when population rose to such a level that some measure of community structure and government was necessary. A courthouse was built for the county lawmakers. In 1742, Hanover County was divided, and the newly created county was named Louisa County. Local government developed slowly as it was needed by the people.

The Anglican Church (Virginia, as a colony of England, was Anglican) created a new parish to accommodate Louisa County. The new parish was taken from St. Martin's Parish of Hanover and Goochland. It was named Fredericksville Parish and its boundaries were similar to those of the county. At that time the residents of the county were governed by twelve vestrymen of the parish and fourteen men selected as justices of the peace. These two groups ran the county at the behest of the king of England.

In the early days of the county, Louisa County was very insular, and the transportation of people and goods to and from the area very difficult. For this reason, homes were built of local materials (primarily wood) and those items that could not be home-grown were supplied by merchants and local mills.

The Revolution was fully supported in Louisa, and local heroes soon emerged. Patrick Henry represented Louisa County in the House of Burgesses from 1765 to 1769 and Dabney Carr from 1772 to 1774. Mr. Carr was responsible for the presentation of the resolution recommending the creation of a Committee of Correspondence, which was a first step in uniting the Colonies before the Revolution. During the war, another local hero, Jack Jouett Jr., rode the 38 miles from Louisa to Charlottesville to warn Thomas Jefferson and members of the Virginia General Assembly that the British were coming after Richmond had fallen.

After the Revolution Louisa settled down to the business of creating a new government free from British influence. By 1818 a new courthouse and a jail had been built, but at this time roads were still so poor that citizens had difficulty getting to their own courthouse, not to mention to places outside of the county. Louisa County remained fairly quiet until well into the nineteenth century, but the arrival of the railroad changed everything.

In 1838 the Virginia Central Railroad reached Louisa Courthouse (the first name of the town of Louisa) and by 1840 it afforded travel through the county. With the advent of the railroad, materials and people traveled more easily.

During the War Between the States the Central Virginia Railroad was vital to the supply lines of the Confederate troops, and it was for this reason that Louisa County endured Stoneman's and Dahlgren's raids. The railroad was also the cause for the clash of cavalry at Trevilians in 1864. Despite many attempts by the Union troops, they never made it through Louisa to the hub of railroad activity in Gordonsville.

The era of Reconstruction in Louisa County was responsible for many changes, but also for a feeling of resentment which lasted a long time. The military occupation by Major General Alvin Coe Voris was not oppressive but the mere fact of occupation offended the local populace. One positive result of the new Virginia government was the new public school system. Littleberry Haley, as first superintendent of schools, brought education to the county. It was also about this time that the town of Louisa was incorporated.

Before the turn of the century the town of Mineral was developed by mining interests in the county. Mining had been an ever-present industry in Louisa County, and area rich in many minerals. Even gold mining existed at one time on a small scale.

From the turn of the century through World War I to the end of the 1920s, Louisa County saw many changes. With the help of the Department of Agriculture, farming methods were improved and updated. These years were a time of great change in quality of life for residents of Louisa County. A new courthouse was built, roads were improved to accommodate cars and, with the introduction of the telephone, communication was improved. Schools were built throughout the county for black and white students.

The Great Depression which resulted from the stock market crash of 1929 brought many federal services to Louisa County, for example, the Rural Electrification Administration brought electricity to the far-flung farms. The closing of the banks was hard on the local farmers but most managed to survive.

World War II involved many residents in all the theaters of the war: Europe, Asia, and Africa. At home rationing and inflated prices were dealt with and endured.

In the 1960s and 1970s Louisa County saw great changes take place. In 1967 the Twin Oaks Commune was established by eight members. It is one of the country's oldest communes still in existence. In 1973, Greensprings was named a National Landmark District—the Greensprings National Landmark District. The area contains an "assemblage of rural architecture that is unique in Virginia." When Virginia Power built the North Anna Nuclear Power Station in 1970, Lake Anna was created. Lake Anna is a 13,000-acre man-made lake which is used by residents and vacationers for a wide variety of recreational activities.

Louisa County is made up of 514 square miles and has a population of 23,250 people. It is still considered an agricultural and rural county but it is one of the more rapidly growing counties in Virginia.

The town of Louisa can be said to have begun in 1774, when the first official recognition of a 2-acre courthouse area was recorded. The land surrounding the courthouse plot consisted of 397 acres, and was called the courthouse tract. It was privately owned, and in 1763 the tract was in the hands of Thomas Johnson. Taking advantage of his proximity to the courthouse, Thomas Johnson ran a tavern to accommodate the people stopping over on county business. This, and subsequent taverns, formed the core of the nascent town.

In 1807 the heirs to Johnson sold the courthouse tract to Henry Lawrence, and it was during his ownership that the first pieces of land were separated from the courthouse tract. Lawrence sold one acre each to Benjamin Willis and Alexander Levy (a Frenchman), but to make sure no competition for his tavern developed, Henry Lawrence placed restrictions on all land bought from the courthouse tract: "It was agreed between the parties that the said Levy, nor any other person for him, or claiming under him or his heirs, should sell or suffer to be sold, any thing that might in any way interfere or injure the said Lawrence Tavern kept at the said Courthouse (to wit) the said Levy should not keep on the said lott of ground, a tavern, boarding house, stabliage, nor in any manner retail spirits of any kind, wines of any sort, Beer, Porter, cyder, or

any sort of drinks made thereof and that he should not keep a house of entertainment." These restrictions remained in place until 1904.

According to *Martin's Gazetteer*, by 1835 the town of Louisa consisted of the courthouse, a jail, a large place of worship, four stores, a silversmith, a blacksmith, two carriage makers, two tailors, a shoemaker, a cabinetmaker, a saddler, two taverns, a milliner, two lawyers' offices, and a physician. Most of these businesses were on rented land. From this base the town of Louisa grew, with the fastest growth taking place after the arrival of the railroad in 1838.

Elisha Melton owned the courthouse tract from 1840 until his death in 1854. He donated land to Baptists, Methodists, and Reformers for the purpose of building churches. Apart from these donations, the land remained intact under his ownership.

In 1854 the courthouse tract was bought by a group of land speculators: Peter W. Dudley, John C. Cammack, Joseph R. Madison, George W. Trice, David M. Hunter, William Henderson, and William Chiles. By 1856, the land was in the hands of John C. Cammack, William Chiles (later Cammack's brother-in-law), and William Henderson. John C. Cammack was mainly responsible for the division of the land into separate, privately owned parcels. The division was begun before the War Between the States but accelerated after the war ended. Lots sold for residential and business purposes extended beyond the Main Street and crossed the railroad tracks into what was then considered the suburbs. The railroad tracks ran parallel to Main Street, which at that time was no longer than three city blocks, so the suburbs were no more than a block away.

An act to incorporate the town of Louisa in Louisa County was approved on March 8, 1873, by the Virginia General Assembly. Under the act a plat of the town was made with trees, stones, stables, and yards as markers. Seven trustees were chosen to make up the first town council. The trustees were: George J. Sumner (the president), Hyman Levy, F.W. Jones, Jesse W. Melton, Henry E. Murray, Dr. Guilielmus Smith, and Samuel H. Parsons. The council was empowered to pass bylaws and ordinances to govern the town. It was also responsible for keeping the streets in order, opening new streets, and the upkeep of the streets, and for these purposes the trustees were empowered to tax the residents. From this humble beginning the town government began.

On January 8, 1888, the town of Louisa was struck by a fire which left most of the business district in ashes. It took some time for the town to rebuild, but when construction was begun, brick buildings were built to replace the old wooden ones. Several of these buildings still stand today. It was also in 1888 that the town changed its name from Louisa Courthouse to Louisa.

One of the reasons the fire spread so quickly was the lack of a central water supply. Individual wells and the public well accounted for the water supply at the time. In 1926, the present water system was installed, and a volunteer fire department was created. The old fire department building was constructed in 1929. The 1920s saw other improvements, such as the construction of a cement road down Main Street, the installation of a small sewer system, and the rebuilding of the local high school.

In 1951 the number of inhabitants in the town of Louisa increased when land was annexed. The town had begun with "around 250 persons" in 1873 and the population stayed close to that for many years. By 1970 there were only 633 people in the town but in 1977 a second annexation almost tripled the land area of the town. Today the population of the town of Louisa is about 1,350 people in a 1.88-square mile area. This increase is due to Louisa's role as an administrative and commercial center for the surrounding area.

As the town of Louisa modernizes and grows it is important to hold on to the past to help guide us in the future. As the fast food restaurants encroach on the peripheral areas of the town and we realize how many homes and businesses have already been lost, we should see these changes as a reminder that we must think before we allow any more of our history to be lost.

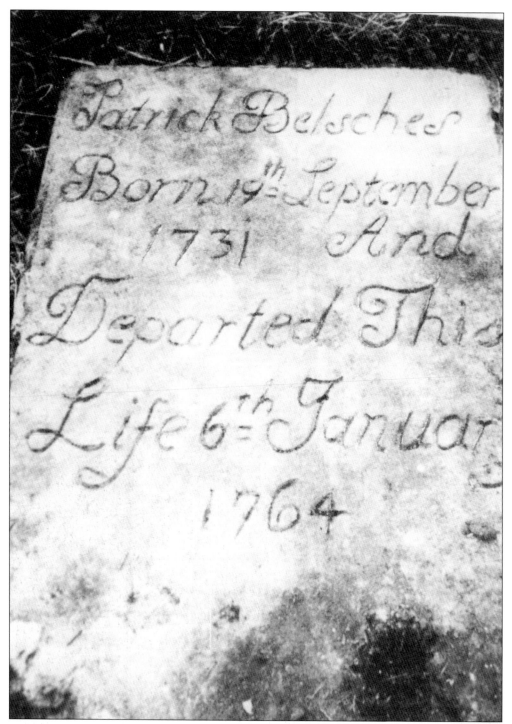

PATRICK BELSCHES' GRAVE The gravestone from Patrick Belsches' grave is one of the oldest in Louisa County. In the early days of the county, possibly before the county existed in name, Mr. Belsches ran a trading post where he traded furs and sold gunpowder. The gravestone is located at the site of the old Hollowing Creek Episcopal Church. (LCHS)

One
Louisa County

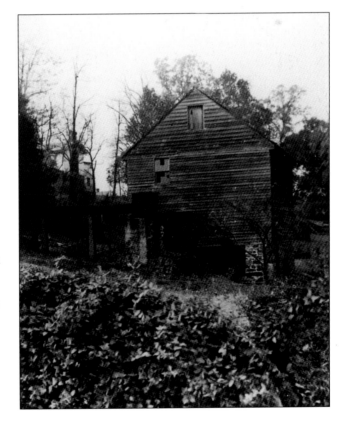

VALENTINE'S MILL
Valentine's Mill on Poor Creek is representative of the many mills which were necessary for the survival of the early settlers in Louisa County. There were numerous mills in Louisa County, including Yanceyville Mill, the only mill in Louisa County which has been in continuous operation since it was built. (LCHS)

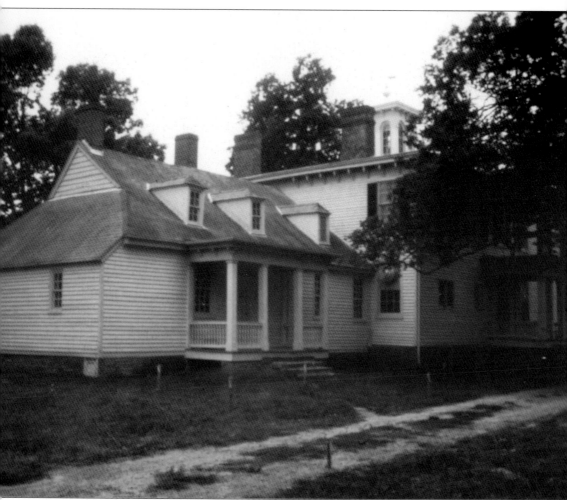

JERDONE'S CASTLE The earliest part of Jerdone's Castle was built in the mid-eighteenth century by Scotsman Francis Jerdone. Francis Jerdone came to Louisa in 1740 and operated several stores, mills, and a forge. He was one of several Scottish merchants who became middlemen for the early colonists. He provided goods and services as well as shipping out the colonists' products for sale. His service was a vital one that was important to the growth of Louisa County. (LCHS)

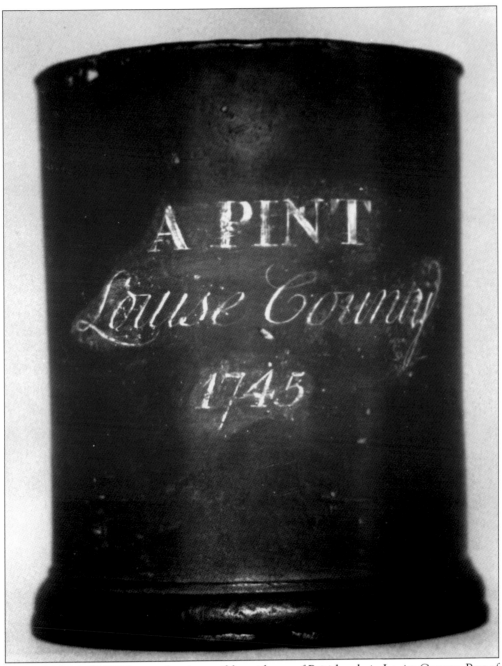

THE LOUISA PINT This artifact is tangible evidence of British rule in Louisa County. Part of a set of measurements, it was used as a standard pint. If anyone doubted what a taverner served they simply brought the offending mug to the courthouse to test it against the standard. British rule affected every part of colonial life and ensured that the King got his share of profits. (LCHS)

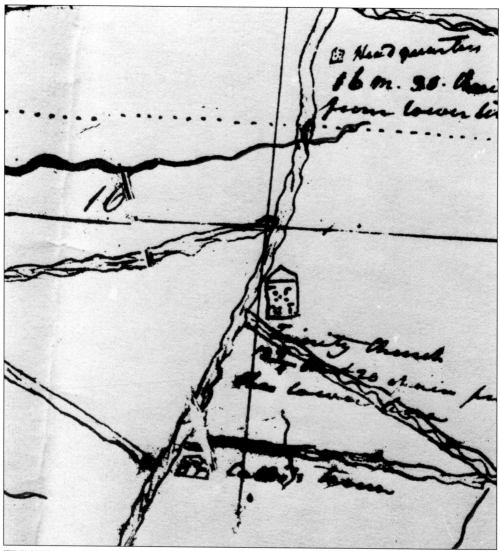

TRINITY CHURCH Trinity Church, shown here on an 1804 map of Louisa County, was the first Anglican church in Louisa County. Parish lines for Fredericsville Parish of Louisa County were formed about the same time as county lines and covered approximately the same area. The creation of parishes around Anglican churches was yet another form of British control over the colonies at a time when religious freedom did not exist in Virginia. (LCHS)

PROVIDENCE PRESBYTERIAN CHURCH Providence Presbyterian Church near Gum Springs was begun about 1747 as a meeting house. Samuel Davies was the first preacher after the Act of Toleration. The first classical school in Louisa was taught at the church by John Todd, who also preached there from 1752 to 1793. Presidents Madison and Monroe both attended this school. The church is still in use today. (LCHS)

BEAR CASTLE Bear Castle was the birthplace and childhood home of Dabney Carr. Carr (1743–1773) was a young Louisa statesman responsible for the introduction of the Committees of Correspondence, which represented a step in the unification of the colonies. Carr was one of the first members of the committee. He married the sister of Thomas Jefferson in 1765. Bear Castle, overlooking the North Anna River and Elk Creek, still stands today. (LCHS)

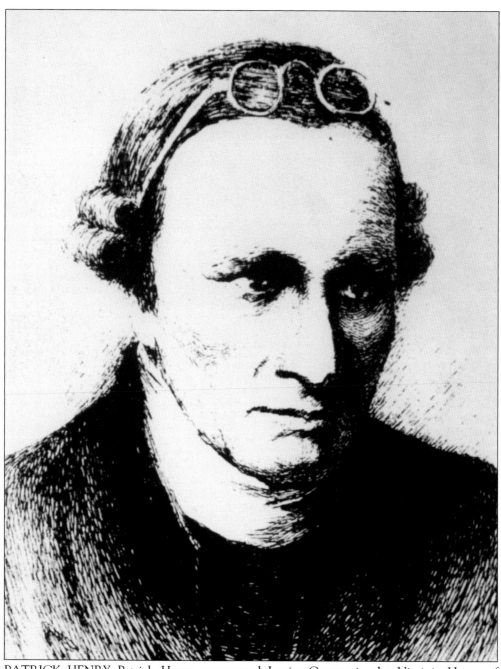

PATRICK HENRY Patrick Henry represented Louisa County in the Virginia House of Burgesses from 1765 to 1769. Though born in Hanover County, Patrick Henry achieved prominence through his service to Louisa County. In 1763, Henry made his first inflammatory speech against the King of England. In a case fought at Hanover Courthouse, Henry argued against the Louisa minister Reverend James Maury, who sought to collect back pay from the Louisa Vestry in what became known as the Parsons' Cause. In this cause, Patrick Henry stood with the Louisa County sheriff and justices of the peace against the wishes of the King of England. Henry won the case and never looked back. (LCHS)

ROUNDABOUT Roundabout was the Louisa County home of Patrick Henry. It was named after the creek which passed nearby. In 1765, while he lived at Roundabout, Patrick Henry spoke out against the Stamp Act in 1765 stating, "If this be treason, make the most of it." (LCHS)

JACK JOUETT Jack Jouett was the grandson of Matthew Jouett, on whose land the first Louisa Courthouse stood. He became famous in his own right when he made his long ride from Louisa to Monticello in Charlottesville to warn Thomas Jefferson and the Virginia Legislature that the British were approaching. Cuckoo village was the site of the tavern where, on June 3, 1781, Jack Jouett overheard the British plans to capture members of the Virginia Legislature. The legislature had moved to Charlottesville after the capture of Richmond by the British. (LCHS)

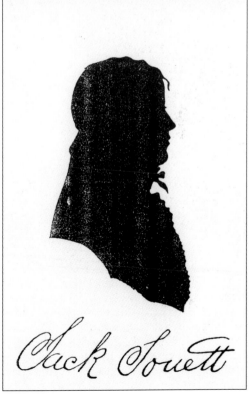

Jack Jouett

REVEREND JOHN AND ELIZABETH POINDEXTER Reverend John Poindexter and Elizabeth Poindexter were very influential in the early days of Louisa County. John Poindexter was the third clerk of Louisa County Court and the first clerk born in Louisa County. He was converted to the Baptist religion by his wife and became a leader in politics and religion. (LCHS)

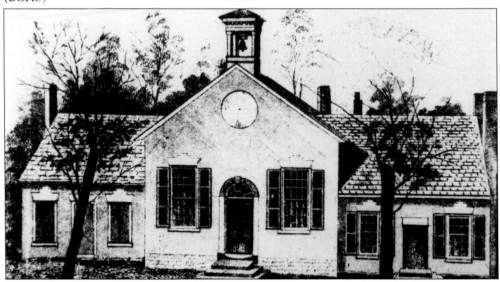

LOUISA COURTHOUSE On the 13th day of May 1816 at Louisa County Court it was decided to build a more permanent courthouse. The buildings in use at that time were probably constructed of logs. Records show the decision made that day: "It is ordered that the Clerk of this Court do cause publication to be made in the Richmond Inquirer & Fredericksburg Herald & also 50 handbills to be struck & circulated giving information that the commissioners heretofore appointed for the purpose of drafting a plan of a Courthouse & Clerk's Offices to be erected in this County. . . ." This building was completed by March 1818 at a cost of $4,300. (LCHS)

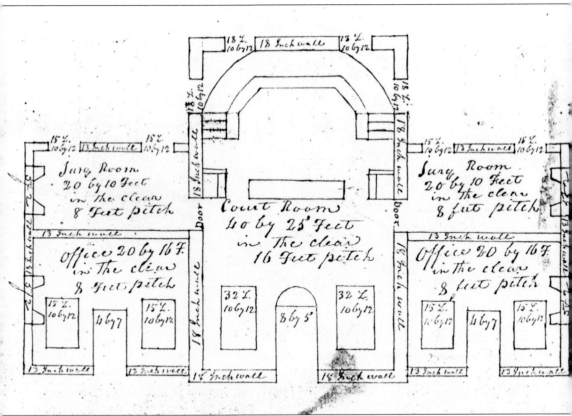

RAGLAND'S ARCHITECTURAL PLAN This interior plan of the proposed new courthouse building was drawn up by Samuel Ragland. Court records dated March 10, 1818, note that: "The commissioners appointed to superintend the building of the New Court House, having made their report, setting forth that the same is completed agreeably to contract, it is ordered that the said report be recorded, and that Samuel Ragland, the undertaker, have leave to withdraw from the Clerk of this Court his bond for the faithful performance of his duty." (LCHS)

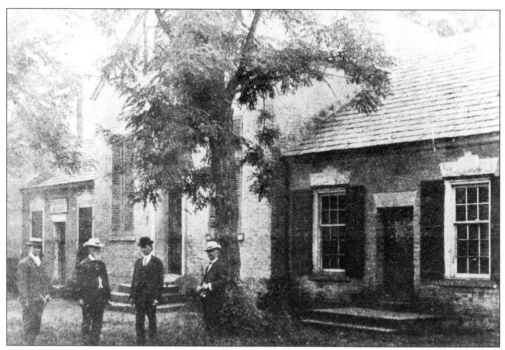

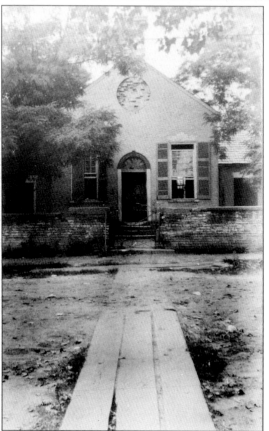

LOUISA COURTHOUSE OFFICIALS
This *c.* 1900 photograph shows the officials at Louisa Courthouse. They are, from left to right: James E. Porter, Jesse J. Porter, R.L. Gordon Jr., and W.R. Goodwin. Jesse J. Porter and James E. Porter, father and son, both served as clerk of court. R.L. Gordon held the office of Commonwealth's attorney in Louisa County for sixteen years. W.R. Goodwin was a deputy clerk and a member of the Louisa Town Council. (LCHS)

LOUISA COURTHOUSE This *c.* 1900 view of the old Louisa Courthouse shows that the condition of the roads in Louisa was poor right up to the turn of century. The roads were often so muddy that the only way to cross them was to use the planks set on top of the mud. (LCHS)

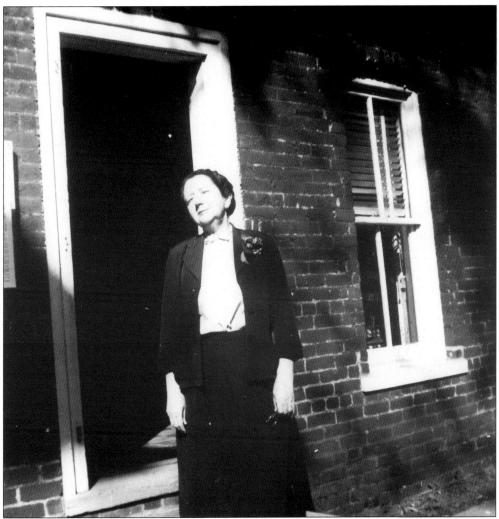

JOSEPHINE NEAL Josephine Neal was a beloved resident of Louisa County who was seen as an authority on the county's history. In this photograph, she is standing in front of the Crank building, which was built about 1832. Court records document the construction of this building: "Lucien Minor, having submitted to the Court, a proposal to build a Lawyer's Office of brick on 20 feet square on the public ground attached to the courthouse. . . ." In 1885 the building was enlarged for W.E. Bibb, the attorney for the Commonwealth. (LCHS)

DR. PHILIP PENDLETON MAY In 1844 the court ordered, "the building of a new clerk's office and the enclosing with a brick wall the said Courthouse and Clerk's Office." Until the present courthouse was built the clerk's office was in a separate building. Here, Dr. Philip Pendleton May stands in front of the wall which was torn down when the present courthouse was built. (LCHS)

JOHN HUNTER John Hunter was clerk of court for Louisa County from 1820 to 1851. It was during this time that most of the changes were made to the courthouse square and Louisa came into her own. For a few years Mr. Hunter also owned between 300 to 400 acres surrounding the courthouse square. (Clerk)

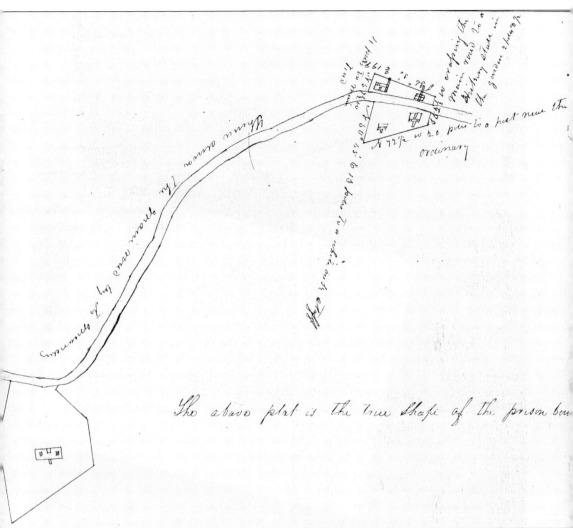

JAIL PLAT The earliest jail, built in 1774, was located several miles from the courthouse. This distance between jail and courthouse proved to be costly and inconvenient. Later several jails were built in the courthouse area, probably of logs. The jails were continually burned down by prisoners trying to escape. Around 1808 a brick jail was built on the north side of Main Street. The exact location of the jail pictured here is unknown. Ten acres encompassed the prison bounds. (Clerk)

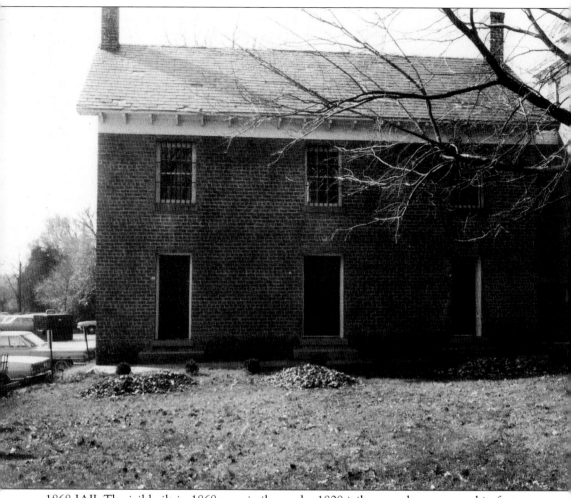

1868 JAIL The jail built in 1868 was similar to the 1808 jail across the street, and in fact was built of bricks and iron taken from the 1808 jail building. Located on public land next to the courthouse, it remained there until 1967, when it was condemned as one of the four worst jails in Virginia. It was then converted to a museum by the Louisa County Historical Society. (LCHS)

JAIL PLAN From this 1808 plan of the jail interior it can be seen that most of the early inhabitants of jails were debtors. Criminal offenders were dealt with directly in the stocks and pilloried outside the jail or whipped. The more serious offenders were often sent to the capital city or quickly hung, saving local jail space. (Clerk)

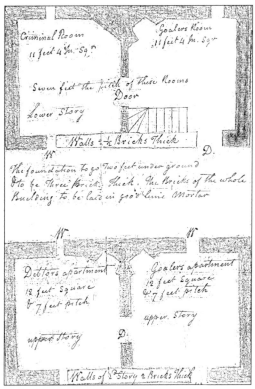

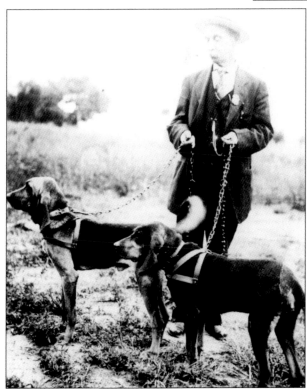

DEPUTY SHERIFF TRICE WITH BLOODHOUNDS Deputy Sheriff J.C. Trice was in charge of the bloodhounds Gay Boy and Gypsy Girl. They were bought in July of 1908 from Sheriff J.R. Wills and sold by the next September. (LCHS)

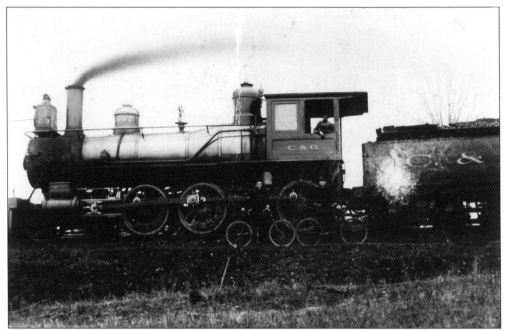

SHIFTING ENGINE AT MINERAL The Louisa Railroad Company built one of the first east-to-west railroad lines. It was surveyed in 1836. The line was completed as far as Gordonsville by January 1, 1840. By 1850 the name had been changed to the Virginia Central Railroad. (LCHS)

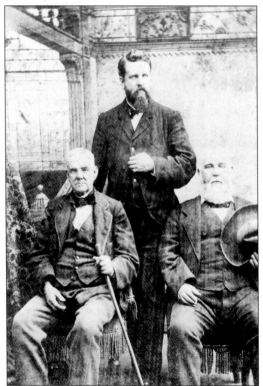

MASON, HOGE, AND GOOCH These gentlemen were railroad contractors hired to build the line and keep it in good repair. The railroad opened up the outside world to Louisa County, as well as bringing new people, goods, services, and work opportunities to the once isolated county. (LCHS)

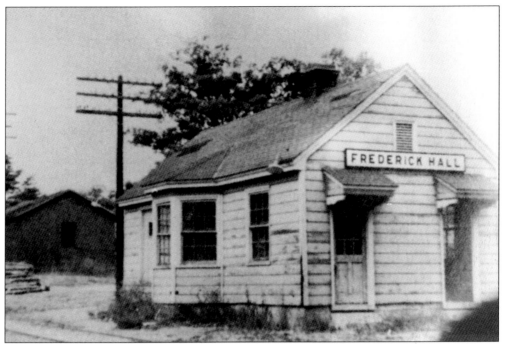

FREDERICKSHALL Frederick Harris of Frederickshall was the first president of the Louisa Railroad. Frederickshall was a terminal of the railroad "whence passengers went on westward by private conveyance." Many people traveled on to the "springs" from Frederickshall in the summer months. The Greensprings section of Louisa County was very popular in the early nineteenth century. (Kib)

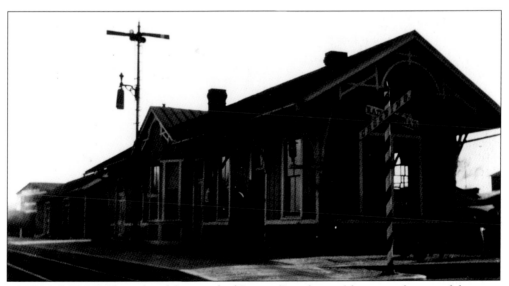

LOUISA DEPOT The railroad first reached Louisa Courthouse (the original name of the town of Louisa) in December 1838, and from that date onwards was a major factor contributing to the growth of the town of Louisa. The Chesapeake and Ohio Railroad Depot, built in Louisa in June 1902, is no longer used by the railroad. (LCHS)

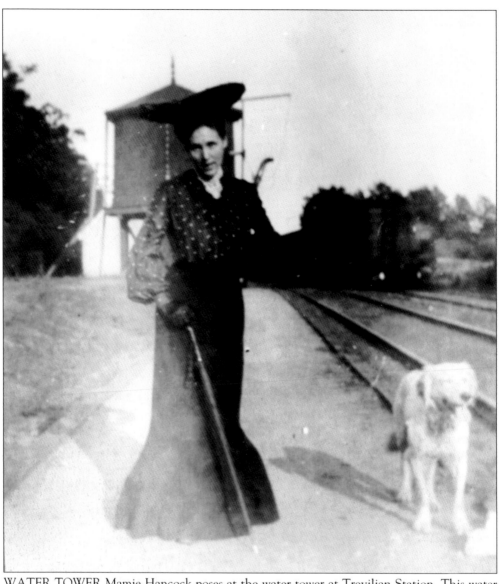

WATER TOWER Mamie Hancock poses at the water tower at Trevilian Station. This water tower was one of many along the line: the old steam engines had to stop often to refill their water tanks. The Trevilian tower was destroyed during the War Between the States. (LCHS)

Two

Confederacy, New Courthouse, and Communities

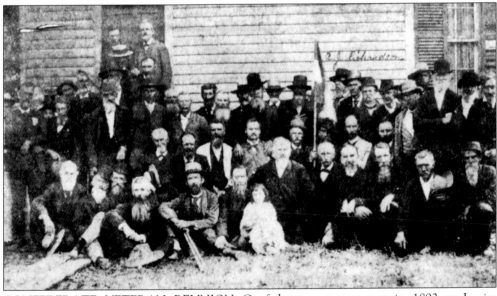

CONFEDERATE VETERAN REUNION Confederate veterans met in 1892 at Louisa Courthouse. In the front row are E.J. Boyd, Charles K. Pendleton, Joe Nucholls, A.T. Goodwin, William B. Pendleton, Henry Chandler, Dr. R.L. Barret and one of his daughters, Mrs. W.S. Jones (at the front and right of him), William C. Barrett, Jesse J. Porter, and Archie D. Arnett. Sitting in the second row are Wallace Cave, Al Baker, W.T. Anderson, Tap Trice, P.M. Hiter (holding the flag), W.E. Bibb, and Pat Mills. Standing are A.D. Driscoll, Sam Crawford, and Bob Harlow. Standing further back are J.M. Beadles, Walker Carpenter, and Thomas Cosby, and right of the flag are General McComb and W.F. Coleman. W.T. Meade and F.V. Winston are in the doorway. In the last row are John Trice, John M. Thomas, Richard Roberts, J.C. Hart, J.B. Walton, A.J. Richardson, and John W. Nunn. (LCHS)

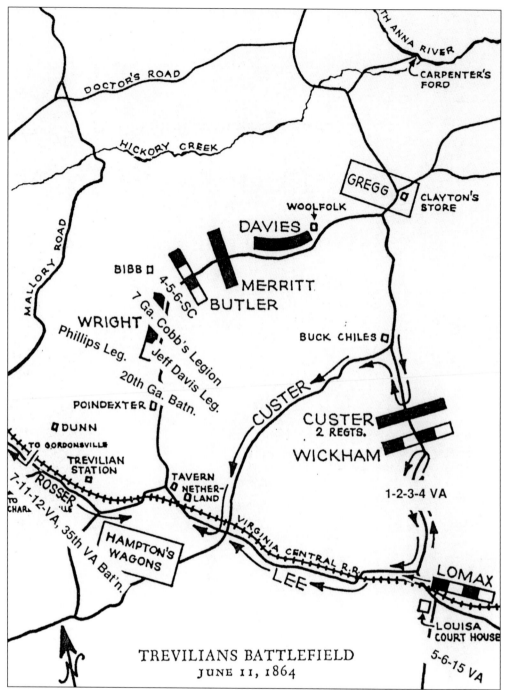

TREVILIANS BATTLEFIELD
JUNE 11, 1864

BATTLE OF TREVILIAN STATION The Battle of Trevilian Station was between the Cavalry Corps of the Army of Northern Virginia under General Wade Hampton and the Union Cavalry under Philip Sheridan. The Union objective was to destroy the Virginia Central Railroad west of Louisa and then to join General Hunter. The Confederate objective, of course, was to stop Sheridan. On June 11, 1864, most of the fighting was in the vicinity of Trevilian Station itself and it ended with Sheridan apparently having the upper hand. (LCHS)

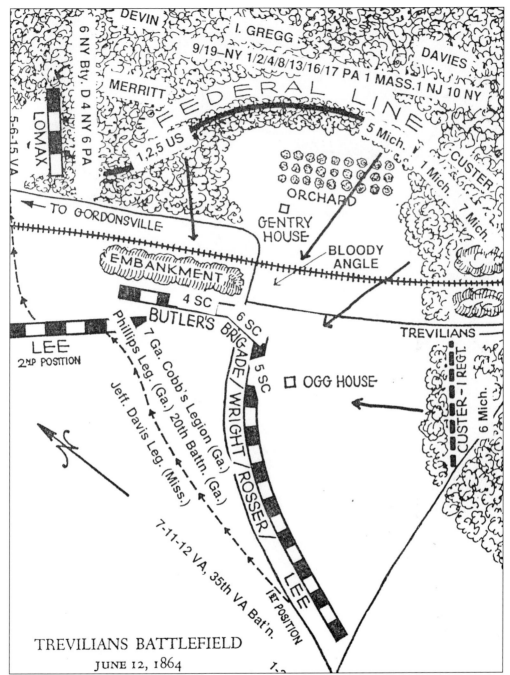

TREVILIANS BATTLEFIELD
JUNE 12, 1864

BATTLE OF TREVILIAN STATION On June 12, 1864, after a full day's fighting about a mile west of Trevilian Station along the Gordonsville road (now U.S. Route 33), Sheridan was forced to make a general withdrawal after he was outfought. He was then harassed by Hampton all the way to the Union lines. Although the Northern troops were able to tear up about 3 1/2 miles of track, trains were able to run by June 24. Each side claimed victory, but since Hampton achieved his objective and Sheridan didn't, it appears to have been a Confederate tactical victory. (LCHS)

CARTER SCOTT ANDERSON Carter Anderson brought to life his experiences as a conductor on the Virginia Central Railroad in *Trains Running for the Confederacy 1861–1865*. The Virginia Central was a vital supply line during the War Between the States, with Gordonsville at the hub. The railroad men were conscripted to run the trains for the Confederacy. (Cooke)

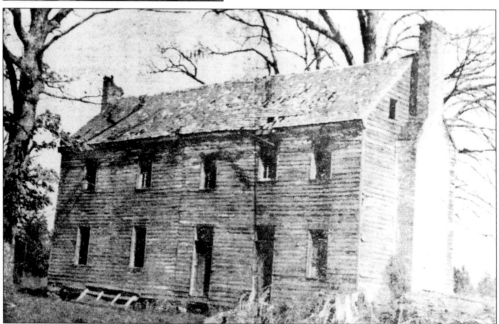

NETHERLANDS TAVERN On June 10, 1864, the eve of the Battle of Trevilian Station, the Confederate General Wade Hampton spent the night fully dressed on a carpenter's bench near Netherlands Tavern. When brigade commanders asked him his intentions in the morning, his reply was, "I propose to fight." (Kib)

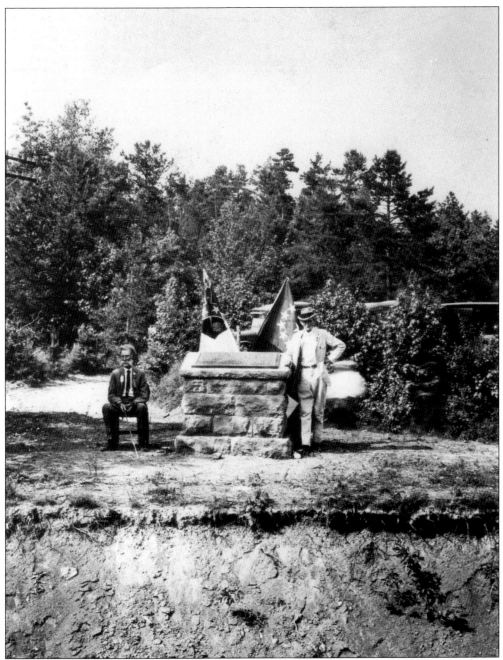

TREVILIANS DEDICATION In 1926, the United Daughters of the Confederacy organized the erection and dedication of a marker commemorating the Battle of Trevilians Station. The marker was later moved from this spot to its present position near Route 33 and Route 22. (LCHS)

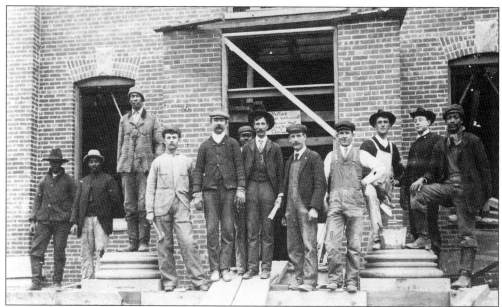

CONSTRUCTION OF LOUISA COUNTY COURTHOUSE Construction of the present Louisa County Courthouse was started about 1904. The bricks that were used to build the front foundation were taken from the wall which formerly surrounded the court green. Among those in this photograph are, from left to right: (starting with the men on the planks) Mr. George H. Leigh, Robert Leigh, and Elgin C. Morris (master carpenter on the project). (LCHS)

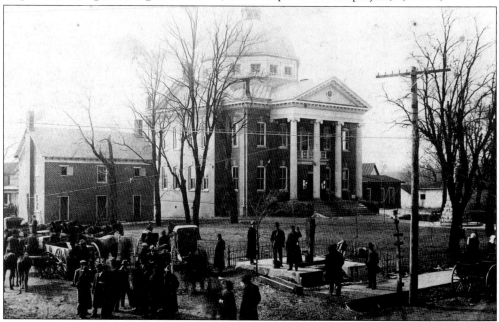

LOUISA COUNTY COURTHOUSE The new courthouse was planned by D. Wiley Anderson and C.K. Howells, Architects. It was built behind the old clerk's office and occupied as fast as construction would permit. The dedication ceremony for the courthouse and monument was held on Thursday, August 17, 1905, at which time, it was ruled, "no cider of any kind be sold within the corporate limits of said town." (LCHS)

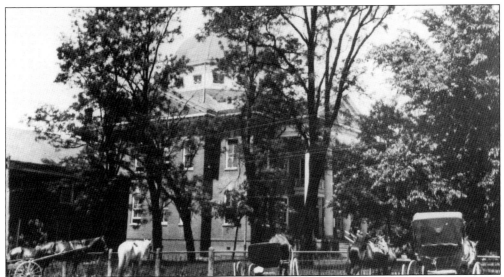

HORSE RACKS AT THE COURTHOUSE On December 11, 1905, Ashton Stark presented his bill for building an iron fence around the courthouse. A 1907 entry in the supervisor's journal indicates that the fence was being used for all kinds of purposes: "It appearing to the Board that the Iron Fence enclosing the Courthouse yard is being used as a hitching post for horses and the said court yard is being used as a playground. . . ." Both uses were subsequently forbidden and, later, a rack was built for the horses. (LCHS)

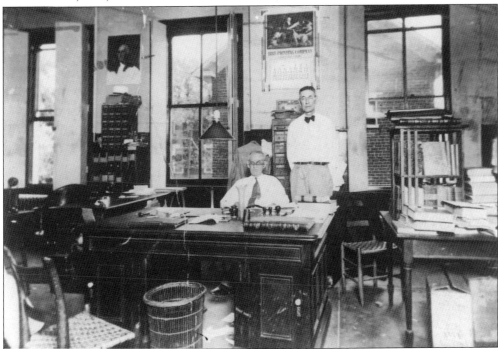

COURTHOUSE INTERIOR The original clerk's office was just one room in the new building. Here Philip Porter, clerk, and his deputy, John Thomas, pose in their office. Philip Porter was clerk from April 1913 until 1935. He succeeded his father, Jesse Porter, and his brother, James E. Porter, in the role. (LCHS)

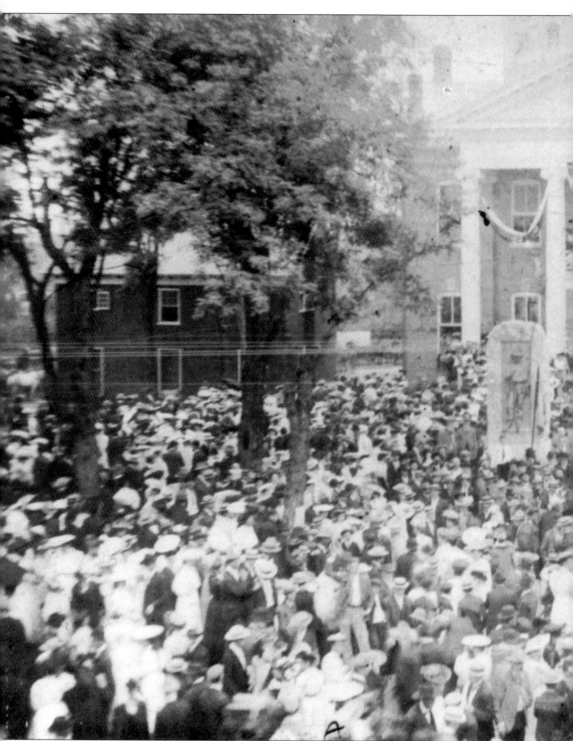

COURTHOUSE AND MONUMENT DEDICATION On September 29, 1903, it was ordered that, ". . . the Memorial Association be permitted to erect a Confederate Monument upon the Courthouse Public Square." The monument was designed by Mr. William L. Sheppard. Some

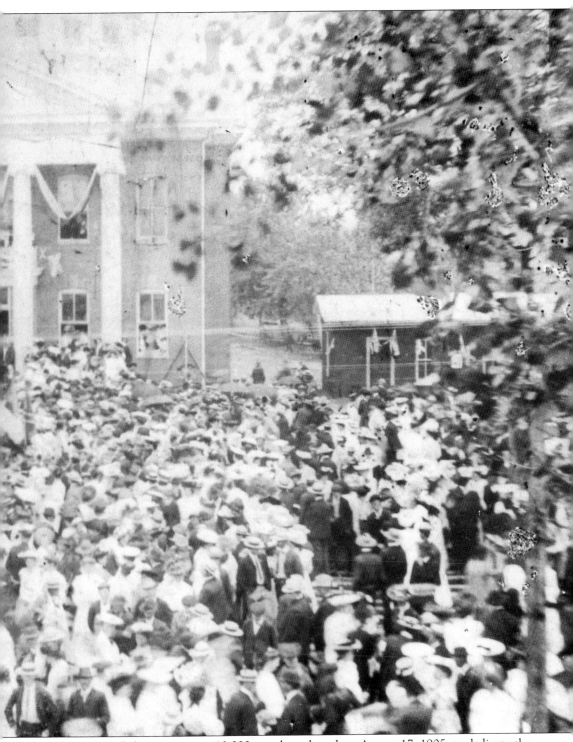

people estimated that as many as 10,000 people gathered on August 17, 1905, to dedicate the courthouse and monument. (LCHS)

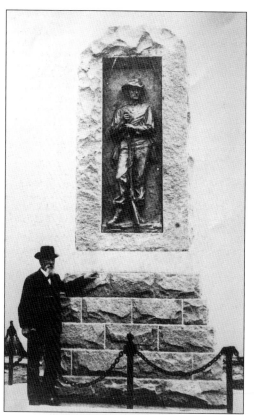

CONFEDERATE MONUMENT Jesse J. Porter stands beside the Confederate Marker that was dedicated on August 17, 1905. The Louisa Confederate Monument Association was made up of Mrs. Jesse J. Porter (president), Mrs. Charles E. Hughes, (first vice president), Miss Ellen H. Kent, Mrs. Floyd Chaney (second vice president), Miss Ellen H. Kent (secretary), and Mrs. Wilmer Sims (treasurer). (LCHS)

REUNION OF CIVIL WAR VETERANS These Civil War veterans gathered together at the dedication of the Confederate monument. Among those pictured are, from the left: (third step) Jesse J. Porter (5th), W.J. Jones (7th), George Hillman (9th), and Frank V. Winston (10th); (next row back) Charles Loehr (2nd), George David M. Hunter (10th), W.E. Bibb (end of row). Dr. P.P. May stands second from the right between the columns. (LCHS)

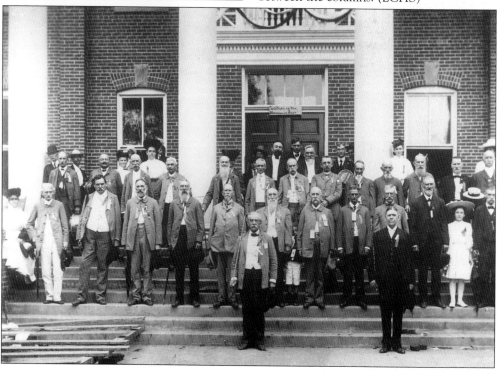

PUBLIC OFFICIALS Chester B. Meridith, (deputy treasurer), John Q. Rhodes Jr., and J. Aubrey Kent pose for Mae Bailey Pettit about 1935 at the Confederate monument. Notice the Louisa water tower in the background. (LCHS)

CLERK OF COURT John M. Thomas Jr. was the deputy clerk in 1935. He was appointed clerk *ex officio* upon the death of James E. Porter on February 17, 1913. He resigned on April 1, 1913, and Philip Barton Porter was appointed clerk. (LCHS)

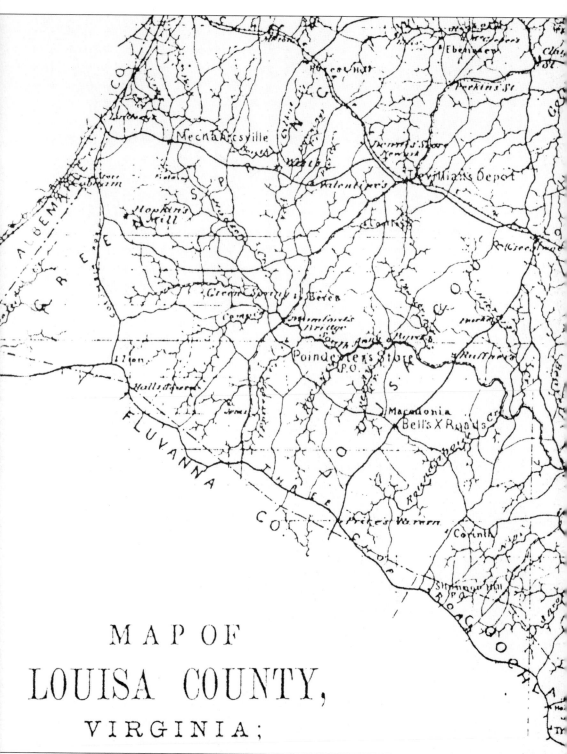

MAP OF
LOUISA COUNTY,
VIRGINIA;

MAP OF LOUISA COUNTY IN 1871 Jed. Hotchkiss, a topographical engineer from Staunton, Virginia, made this map of Louisa County. The map listed churches and mills and

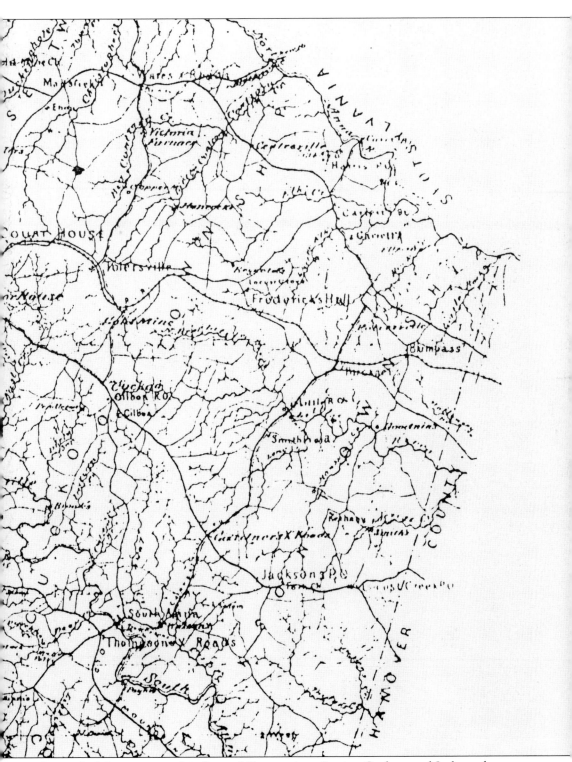

also marked the new township lines of Greensprings, Louisa, Cuckoo, and Jackson that were drawn during Reconstruction. (LCHS)

MELTON'S VIRGINIA G.W. Cooke moved to Melton's Virginia, opened a small store, and applied for a license as postmaster. No more than this was necessary to establish one of the local post offices which sprang up around the county. George Cooke served as postmaster from 1872 to 1908. The house was later demolished. (Cooke)

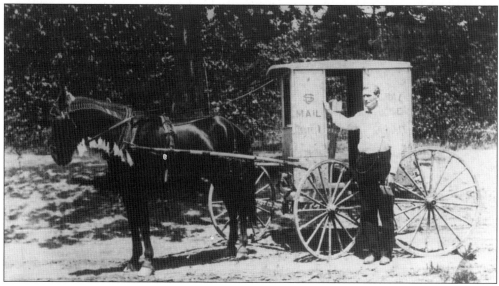

MAILMAN AND CART Organized mail delivery was not possible in Louisa County until 1800, when the first post road was built here. The road, which ran "From Fredericksburg, by Spotsylvania Court House, and Louisa Court House, to Columbia" and connected the Rappahanock and James Rivers, was one of the first post roads. Mail delivery was achieved by whatever means were available. The outfit pictured here is rather fine. (LCHS)

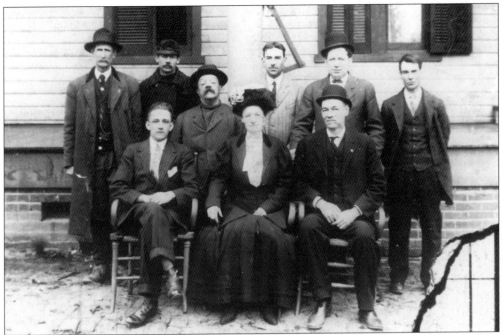

EARLY POST OFFICE WORKERS This photograph, taken *c.* 1912, shows post office staff and rural carriers. In the front row are, from left to right: Wyndham R. Wills, clerk; Mrs. Mamie Woodward Flannagan (1878–1955); and Cordington D. Flannagan (1862–1934), postmaster. In the back row are, from left to right: Jabez Patrick Massie (1855–1925), RFD 2; Robert H. Powell (1878–1973), RFD I; Herbert (Shorty) Poindexter, RFD 5; Charles D. Barret (1872–1924), RFD 4; Willie C. Wright, clerk; Robert Morton Smith Sr., RFD 3. (LCHS)

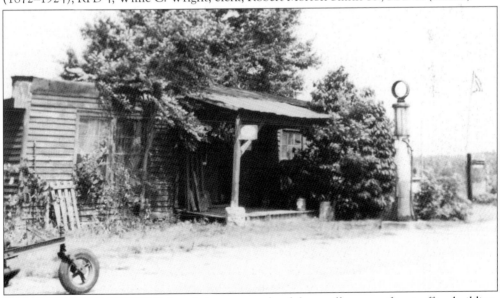

DABNEY'S POST OFFICE Dabney's is an example of the smaller type of post office building. Located in the extreme southeastern corner of Louisa County, it was started in 1878 by Joseph W. Dabney and continued in operation until 1990. This building was closed in 1968 when the post office moved to another building. The property was owned by W. D. Guild. (LCHS)

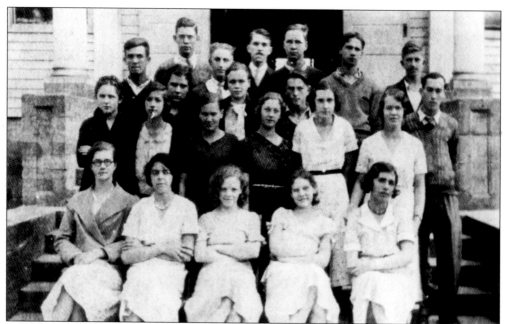

APPLE GROVE AGRICULTURE HIGH SCHOOL Apple Grove was one of the three high schools in Louisa County. Shown in this 1933 photograph are, from left to right: (front row) Rose Maddon Duggins (Massie), Evelyn Marie Bowles, Eloise Elizabeth Hall, Mary Leath Hall (Williams), and Susie Jane Lloyd; (second row) Mary Claybrooke Hart (Lancaster), Helen Josephine Noel, Elizabeth Cox Woolfolk (Mustoe), Mary Louise Quarles (dec), Beatrice Hardenia Noel (Lloyd), and Bernice Alma Brooks (Williamson); (third row) Clifton Blair Brooks, Louise Elizabeth Smith (Gaskill), Ronald Chester Walker, Matlie Elizabeth Clough (Gammon), Harrie Lee Clough (dec), and Raymond Lindsay Parrish; (top row) William Winston Pendleton, Leslie H. Walton (the principal), Clifton Adams Nicholas, Henry Napoleon Perkins, and Albert Partee Walker. (CV)

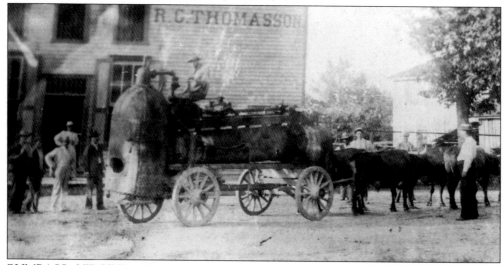

BUMPASS, VIRGINIA R.C. Thomasson's Store (which later became Pleasants Store) at Bumpass, Virginia, is typical of the general merchandise stores which flourished around the county. The building is being used as a home today. (Kib)

44

CUCKOO, VIRGINIA Dr. Eugene Barbour Pendleton, a county treasure, still made house calls at the age of ninety. There have been ten physicians in the Pendleton family who have practiced in the county. At the beginning of his work, Dr. Pendleton traveled by horseback and sleigh; later he drove a Model T Ford. (LCHS)

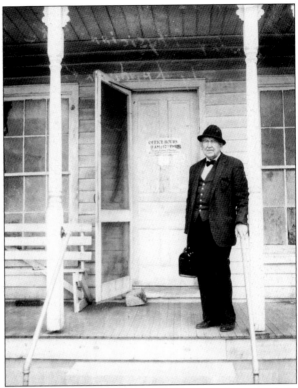

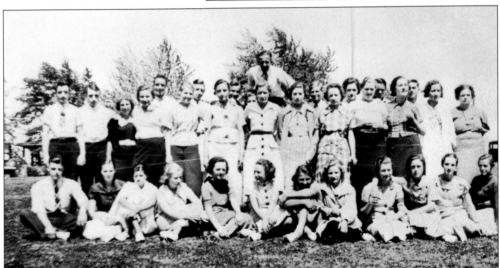

LOUISA COUNTY HIGH SCHOOL CLASSES OF 1936 This photograph was taken in May 1936 just before commencement. The students are, from left to right: (sitting) Bob Collins, Mary Edna Kirby, Lois Carder, Lucy Frances Hunt, Inez White, Virginia Wright, Elizabeth Broome, unknown, Iris Lacy, Ruth Loving, unknown, Mary Lee Shank; (standing) unknown, Porter Whitlock, Dorothy Page, unknown, Nellie Hopkins, unknown, unknown, Vernelle Hester, Bessie Swartz, unknown, unknown, unknown, and Catherine Tomlin; (back row) Franklin Kean, unknown, unknown, unknown, unknown, unknown, Mildred Brockman, Alvin Shumake, and Elwood Knighton. (Gilmer)

45

GREENSPRINGS The Frank T. West family at "Westland" in the Greensprings area. Included in the photograph are: (front row) Frank Thornton West, Mrs. Susan West Harper, Mrs. Charles B. Vest, and Miss Eddie Cosby; (second row) Emma Lyle West, Henry A. Flannagan,

Fritz P. Wills, and Charles Hancock; (third row) Mrs. Emma Wills West, Mrs. Bessie Wills Flannagan, and Mrs. Ariana Chiles West. (LCHS)

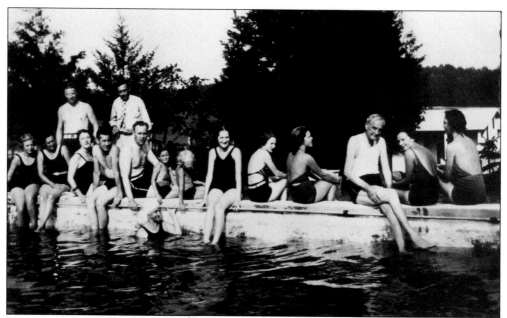

MANSFIELD, VIRGINIA Enjoying the hospitality of the Boxley's Mansfield pool are Annie Gris McIntosh Boxley, Mildred Douglas Porter Boxley, Bruce V. Boxley Jr., Virginia "Momee" Flanagan, Norris Byrd, Jack Flannagan, Joe Porter, Dorothy Douglas Boxley "Didi," Gris Boxley, Donnally, Reese Clark, Margy, Terrell Porter, Mr. Phil Porter, Helen Wright, and Gay Donnally. (Boxley)

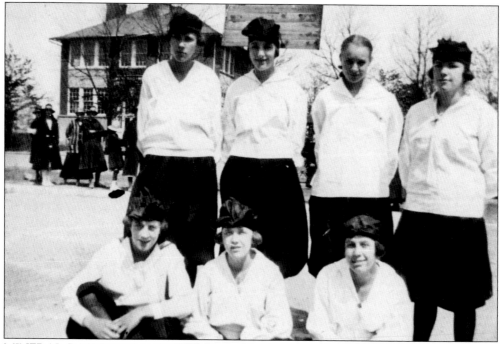

MINERAL BASKETBALL TEAM Included in the team when this photograph was taken were, from left to right: (seated) Thelma Spicer (Wood) and Virginia Spicer (Kennedy); (standing) Gladys Spicer (Barrett), Mary Chaplin (Goodlin), and Louise Harlowe. (Kib)

MINERAL, VIRGINIA The L.A. Keller home at Mineral Avenue and 2nd Street. Originally called "Tolersville," Mineral was created by Mineral City Mining, Manufacturing and Land Company in 1890. Conceived as a great city by local mining factions, it never quite got as big as expected but is much loved by members of the community. (Kib)

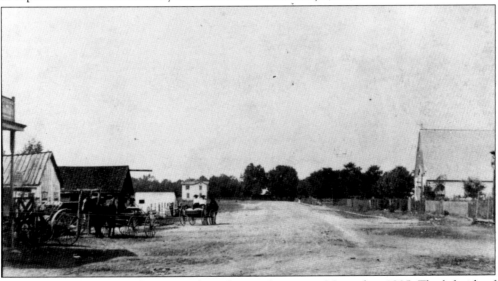

MINERAL, VIRGINIA This image shows Louisa Avenue in Mineral, c. 1905. The left side of the photograph shows an edge of the porch of the D.E. Bumpass building, then a livery stable, and blacksmith Jim Kennedy's forge. In the middle are the Arnette house and Thomas Young (Bailey, Kennedy) house. On the right side of the street is the Episcopal Church, built in 1902. (Kib)

YANCEYVILLE, VIRGINIA This Yanceyville store was run by Leonard Smith and Mann Logan in the early 1900s. It later burned. Established in 1797, Yanceyville was one of the first towns to be established in Louisa County. The Yancey family developed it because it would create a tax advantage for their distillery. It included seven or eight houses, a grist and sawmill, a distillery, a cooperage, a blacksmith, a store, and a tavern. A mill still stands at Yanceyville. (LCHS)

Three
Courthouse Village

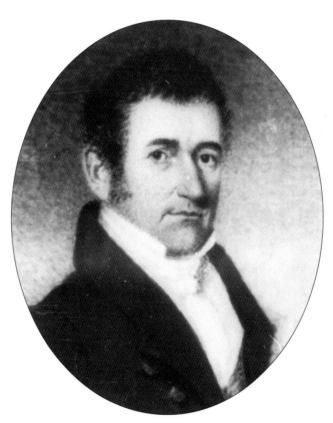

THOMAS JOHNSON Thomas, son of the sheriff Thomas Johnson, was a member of the influential Johnson family that owned the land surrounding the courthouse in the late eighteenth century. This land was called the "courthouse tract," and it contained over 300 acres. The public land on which the courthouse stood was a mere 2 acres of land which was not platted until 1809. The owner of the courthouse tract took advantage of that position by setting up a tavern to ensure that he received all revenues from any visitors to the village on public business. The subsequent owners of the courthouse tract managed to retain a monopoly on the land surrounding the courthouse for at least a century. This picture was taken from a miniature owned by a descendant of Thomas Johnson. (LCHS)

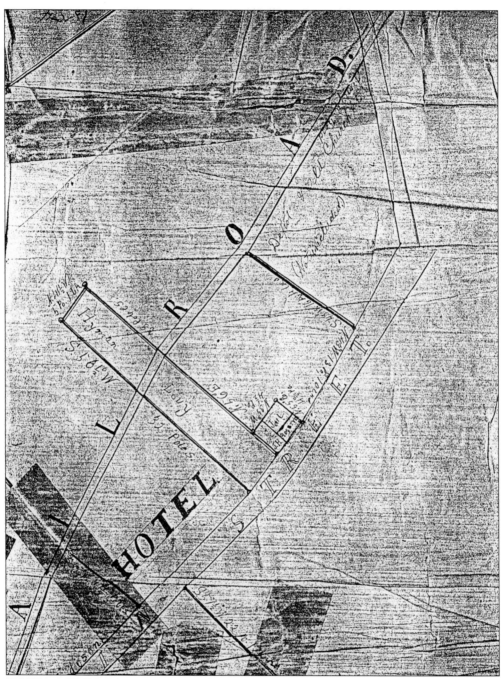

ELISHA MELTON'S TAVERN PROPERTY IN 1854 From 1818, when Henry Lawrence owned the courthouse tract, to the twentieth century, restrictions were placed on all other landowners in the town by the owner of the courthouse tract. Records tell us that no one could keep ". . . a Tavern, boarding house, stablage, nor in any manner retail spirits of any kind Wines of any sort. Beer, Porter, Cyder, or any sort of drinks made thereof . . ." and that other landowners ". . . should not keep a house of entertainment." Elisha Melton owned the courthouse tract from 1841 to 1854; this map outlines his tavern property. (Clerk)

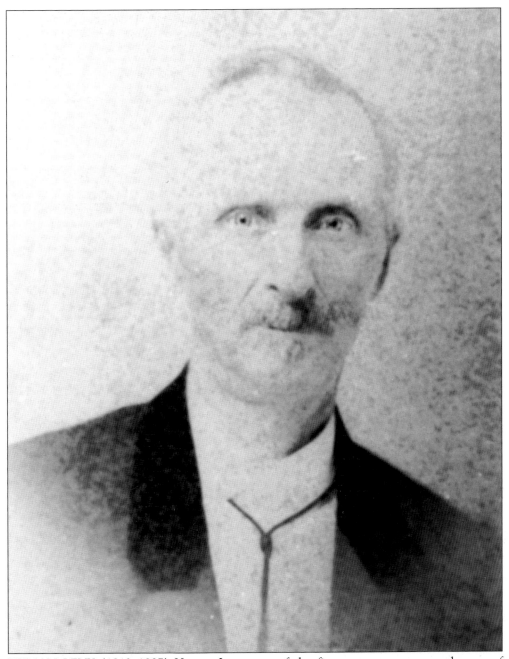

HYMAN LEVY (1812–1887) Hyman Levy, one of the first town trustees, was the son of Alexander Levy. In December 1816 Alexander Levy, an "alien friend" (French immigrant), bought an acre of land from Henry Lawrence. This acre, located almost directly opposite the courthouse, was one of the few pieces of land separated from the courthouse tract at this time. The Levy family retained the land throughout most of the nineteenth century. They ran a shop and lived over it. Today part of that land is occupied by Wright-Loving Furniture & Appliances. (LCHS)

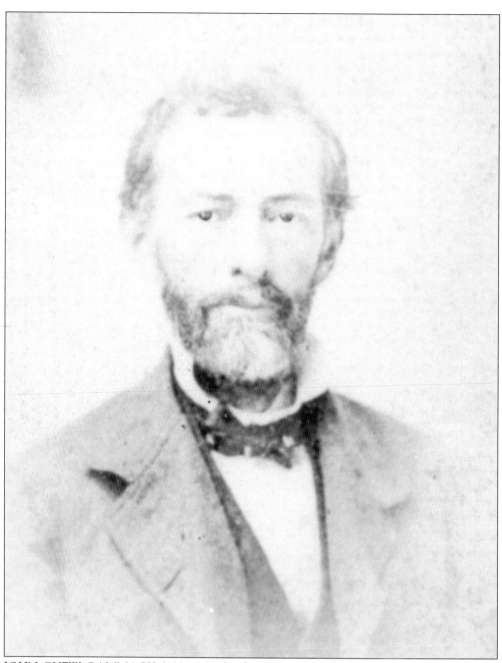

JOHN CHEW CAMMACK (1820–1872) John Cammack came to Louisa around 1854. At that time he, together with several other investors, bought a good portion of the courthouse tract. It was under Cammack's ownership that the division of the town into separately owned businesses and homes occurred. John Cammack later became clerk of the Louisa Court and chairman of the first Board of Supervisors. (LCHS)

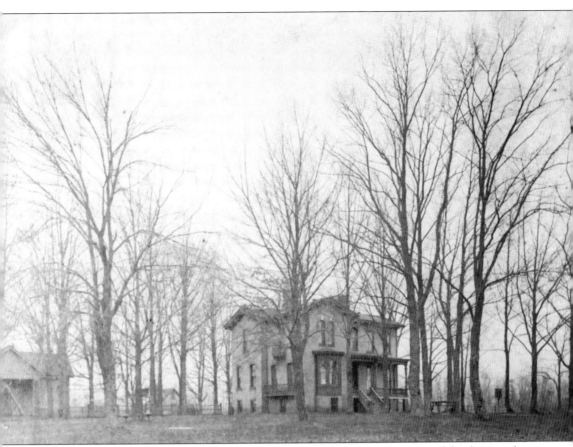

BIBB HOUSE The Bibb House was built on part of a 170-acre tract of land near the courthouse. John Cammack had lived on this tract earlier. The Bibb House was home to W.E. Bibb and his wife Kate Cammack Bibb, the daughter of John Cammack. The house was demolished and the land was later developed as the Epworth Manor Apartments in the Westover Subdivision. (LCHS)

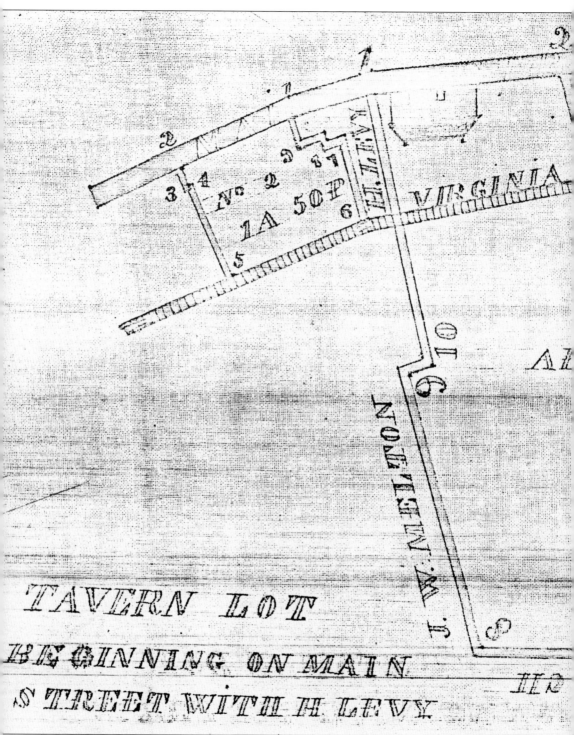

TAVERN PLAT UNDER JOHN CAMMACK The areas marked (1) and (2) represent John C. Cammack's Tavern and Stable property at Louisa Courthouse as they looked when the land was surveyed and plat drawn up by A.J. Perkins SLC on May 23, 1862. Mention is also made on

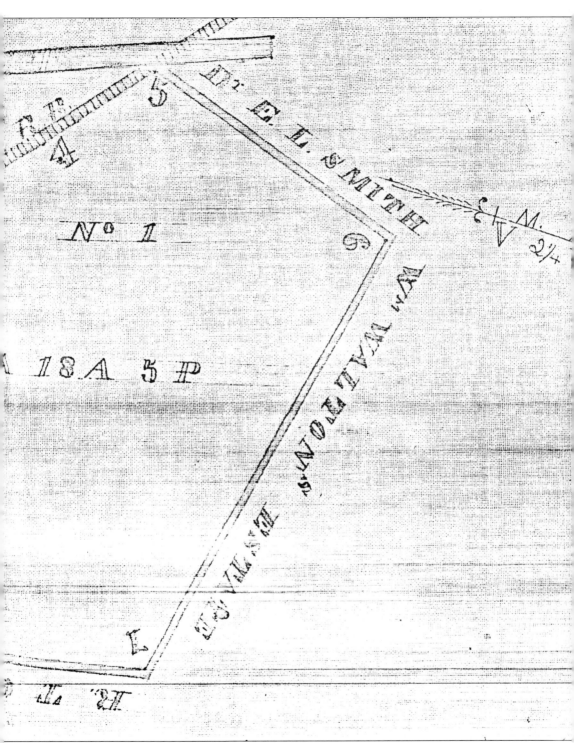

the document of John W. Walker's Store and H.R. Rosson's. Hyman Levy's property was excluded from the tavern property. (Clerk)

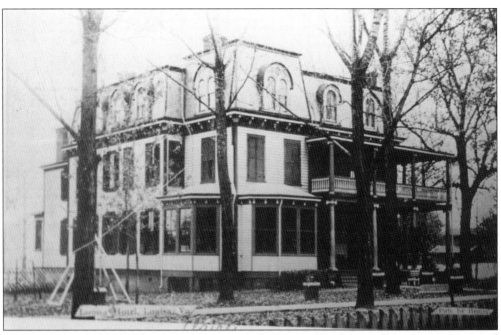

THE LOUISA HOTEL The early taverns and the Louisa Hotel were all in the same general location. The acreage around the present building contained, in earlier times, enough land for the visitor to feel that he was in the country and in town at the same time. When Mr. S.S. Griffith operated the hotel he had a large hardwood platform built outside the dining room windows. Japanese lanterns and little tables were placed on the lawn, while a victrola played for dancing. (LCHS)

OFFICIALLY APPOINTED HOTEL FOR AUTOMOBILISTS WITH GARAGE

HEALTH RESORT

LOUISA HOTEL

S. S. GRIFFITH, PROPRIETOR

ABOVE MALARIA BELT AND BELOW TYPHOID ZONE. WHOLESOME AND PURE ARTESIAN WATER. SITUATED IN THE CENTER OF A LARGE SHADY LAWN. PHONE CONNECTION AND LIVERY WITH GOOD TERRITORY AND DRIVES FOR TRAVELING MEN

RATES $2.00 PER DAY.

LOUISA, VIRGINIA. _April 1ºt_ 1913

HOTEL LETTERHEAD This letterhead was used as an advertisement to attract visitors from Richmond. Louisa was very popular in the summer, as many people came for the country atmosphere. Mr. S.S. Griffith was proprietor in 1913. The hotel also advertised pure milk, fresh eggs, country ham, and famous fried chicken. (LCHS)

PIEDMONT HOTEL FLIER This hotel was called the Piedmont Hotel until about 1901. The present building was built in 1887 by Rice P. Cammack, the son of John Cammack. It was barely saved from a tragic fire the next year. (LCHS)

PIEDMONT ——— HOTEL,

LOUISA, VA.

∴ GREAT RESORT ∴

—FOR—

SUMMER ∴ BOARDERS.

HEALTHIEST PART OF THE STATE. BEST WATER AND CLIMATE. CHURCHES OF ALL DENOMINATIONS IN TOWN.

Every effort made to please and insure a pleasant time to all visitors.

This delightful resort has been recently fitted up and with close at—tention to all wants of guests I hope to give perfect satisfaction.

Terms Reasonable.

Correspondence solicited. Any information gladly given.
Hoping to please,
I am, very respectfully,

GEO. H. JOHNSON,

REFERENCES:

J. J. PORTER, *County Clerk.*	F. W. SIMS, *County Judge.*
W. E. BIBB, *Ex State Senator.*	J. E. BIBB, *Editor Louisa Co. News.*
L. LEVY, *Merchant.*	FLANNAGAN & FLANNAGAN, *Merchants.*
J. W. WILSON, (*firm J. J. Wilson & Co.,*) *Richmond.*	W. D. BUTLER *with G. A. Haynes, Richmond.*

PATRICK HENRY HOTEL New buildings encroached on the hotel property when the surrounding land was sold off. Today the old hotel is an office building owned by William A. Cooke and called the Cooke building. It is a unique building in the area. (LCHS)

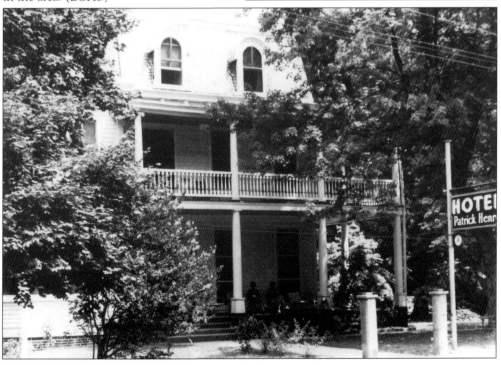

CAPTAIN HENRY W. MURRAY, CSA (1826–1884) Captain Murray was born in Dublin, Ireland. He came to America and became a lawyer, a state senator, and grand master of the Masons A.F. & A.M. of Virginia. He was a member of the first town council of Louisa when the town was incorporated in 1873. (LCHS)

JESSE W. MELTON (1821–1883) Jesse Melton was a nephew of Elisha Melton. As owner of the courthouse tract, Elisha gave Jesse many opportunities in the town. Jesse, a bachelor, became a hotel landlord and did much of the early construction around Louisa. He was also a member of the first town council. He lived on Church Avenue on what is now the fireman's field. (LCHS)

DR. GUILIEMUS SMITH (1830–1901) Dr. Smith came to Louisa County from Spotsylvania County after the War Between the States. He moved into the "suburbs" of the town of Louisa (across the railroad tracks). There he had his home and dental office. He was a member of the first town council. (LCHS)

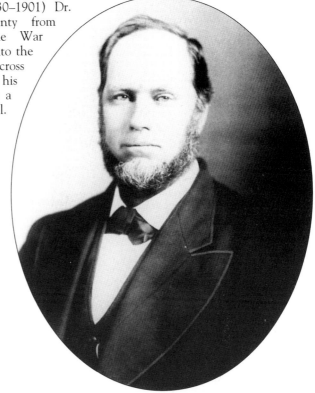

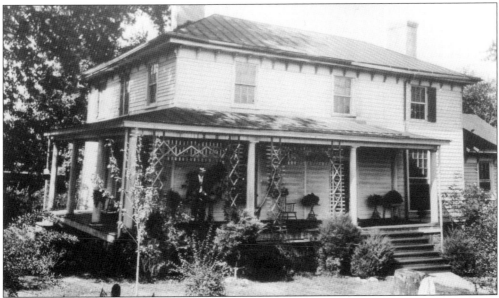

HOME OF DR. SMITH Dr. Guiliemus Smith's house was certainly built by 1867. In the early 1870s a wing was added so that the doctor could receive patients in his home. The windows have initials scratched by the Smith children. Later the house was owned by Sallie Pendleton and then by W.T. Carter. The house, located on Church Avenue opposite the depot, is known as the Carter house by older residents. (Cooke)

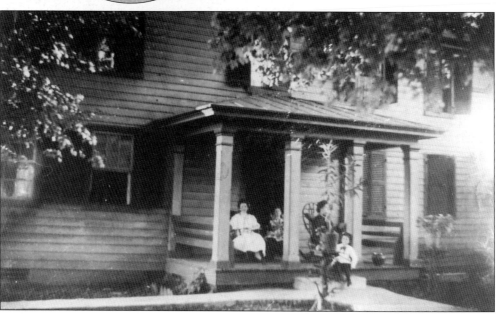

FRANCIS W. JONES Colonel Jones, a merchant, a militia colonel, and the presiding justice of Louisa County, was another of the town trustees on the first town council when Louisa was incorporated in 1873. In 1881 he moved to Richmond. (LCHS)

LIBERTY HALL This house was the home of Colonel Francis William Jones. His son, Reverend John William Jones, a famous Confederate minister, was born here. Located on Elm Avenue, the house was later occupied by Mrs. David N. Walker, who published *The Louisa News and Weekly*, a weekly newspaper. This photograph shows, from left to right: Mrs. Josephine Henderson Neal, Miss Linda Fox Henderson, Mrs. David N. Walker, and Thomas J. Henderson. (LCHS)

LIBERTY HALL This side view of Liberty Hall shows its massive chimneys: little Jimmy Swartz, who stands beside the building, is dwarfed by them. The old home was demolished in 1941. (Talley)

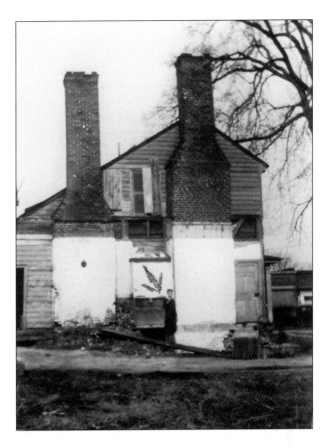

FIRST MAYOR George J. Sumner, a merchant, was the first president, or mayor, of the town. Samuel H. Parsons was one of the original seven town trustees. The trustees were given the power to pass all by-laws and ordinances. They provided for the creation and upkeep of the streets and were also able to levy taxes. Louisa incorporated with a population of 250 residents. (LCHS)

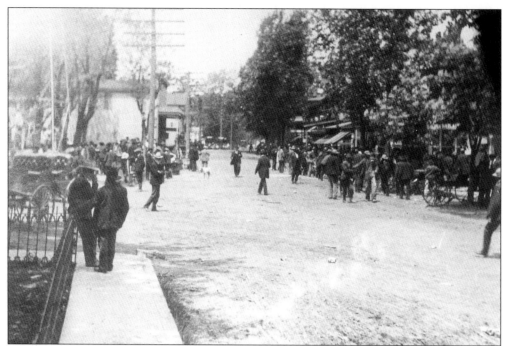

MAIN STREET, LOUISA This *c.* 1920 photograph, taken near the Methodist Church on March Court day, shows the view looking west down Main Street. Notice the tower on the left on the site of the old town well. This windmill was built in 1905, only to be torn down in 1911. Cars were not allowed on Main Street at that time because they scared the horses. (LCHS)

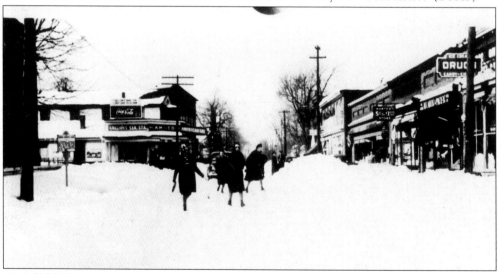

1940 SNOW In January 1940 almost 35 inches of snow fell on Louisa. This picture, taken by Joe Porter, shows local schoolteachers Elizabeth McIvor, Lovell Kiblinger, Dot Deane, and Mrs. H.W. Charlton in the middle of the street. On the right side of the street are the A&P store, Porter's 5¢ to $1.00 Store, Woolfolk's Department Store, the Boxley Building, and W.E. Cunningham's Jewelry Store. On the left side of the street are Zeke Gallion's Service Station, the Old Louisa Movie Theatre, the two-story Gate's Building, and C.E. Hester's Grocery Store (later B.L. Thomas' Grocery). (LCHS)

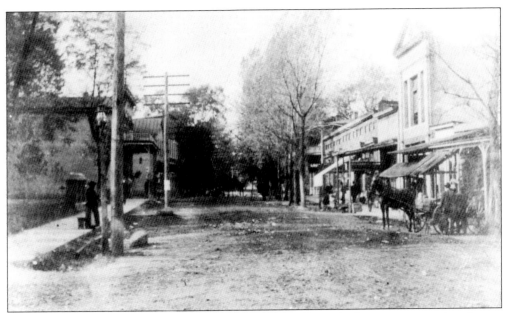

MAIN STREET, LOUISA This *c.* 1911 view of Main Street looking west was printed as an early postcard. The buildings on the right did not change greatly in the next twenty years, but the buildings on the left underwent many changes. Notice the old street lamp on the left just above the man's head. In 1878, the first street lights were installed in twelve positions around town. Mr. W.H. Vaden maintained the lights, arriving each morning with a small ladder, a pair of scissors for trimming wicks, a can of oil, and tissue paper for cleaning the globes. He returned at night to light the globes. (LCHS)

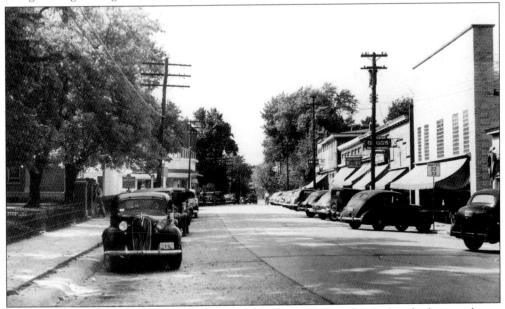

MAIN STREET, LOUISA This picture, taken looking west from a spot beside the courthouse in 1947, captures many of the same buildings as the snow scene. It also shows the building known today as the Jefferson Building. The photograph was taken for use on a postcard that was sold at Porter's 5¢ to $1.00 Store. (LCHS)

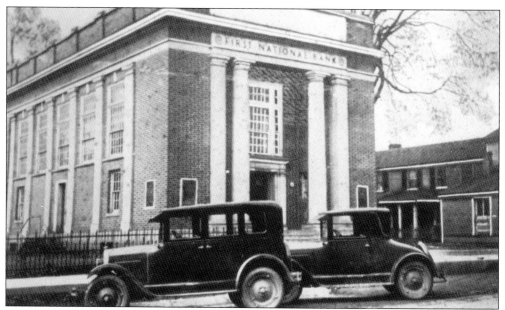

LOUISA NATIONAL BANK The building known today as the Ogg Building was erected as the Louisa National Bank in 1917 at a cost of about $35,000. Liberty Hall can be seen in the background of this photograph. In 1890, Bonavita had a store in the same location which contained Louisa's first soda fountain. Some people believed that Bonavita's store building was a courthouse before 1818. Because of this belief, an attempt was made to prove that the land on which the store stood was public land and therefore not limited by town restrictions. It was, however, determined that the land was not public property. (LCHS)

LOUISA BARGAIN HOUSE The Bargain House was owned by Charles E. Hughes in the early days of the twentieth century. Hughes advertised his store as a "Dry Goods Emporium which is the acknowledged Headquarters of Low Price." Fabric was sold for 2¢ and 3¢ per yard. Once owned by F.M. Bonavita, the building was moved in 1917 to the depot area, where it became part of Henson's Store. (LCHS)

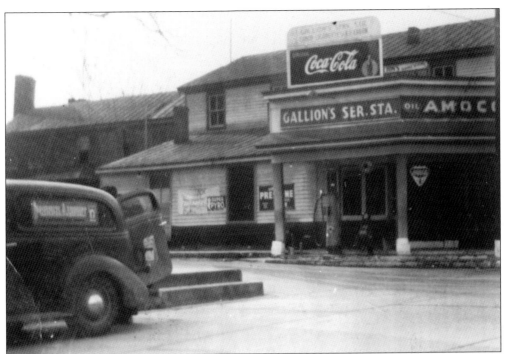

GALLION'S SERVICE STATION Gallion's Service Station was first owned by W.E. Lynch. Later Zeke Gallion operated a grocery store and service station which became known as Zeke Gallion's Service Station. Many of the old stores had rooms above them which were occupied by the owners or rented out. At one point the rooms above Gallion's were used by the Presbyterian Sunday School while their church was being built. The Jefferson National Bank now stands on the site of Gallion's. (Talley)

HUGH TALLEY AND HIS FRIEND BILL PERKINS Hugh C. Talley owned Liberty Hall and the land at the corner of Elm Avenue and Main Streets from 1937 to 1971. He is well known because of his early movie theatre in Louisa. The car is a 1916 Ford Model T Roadster. (Talley)

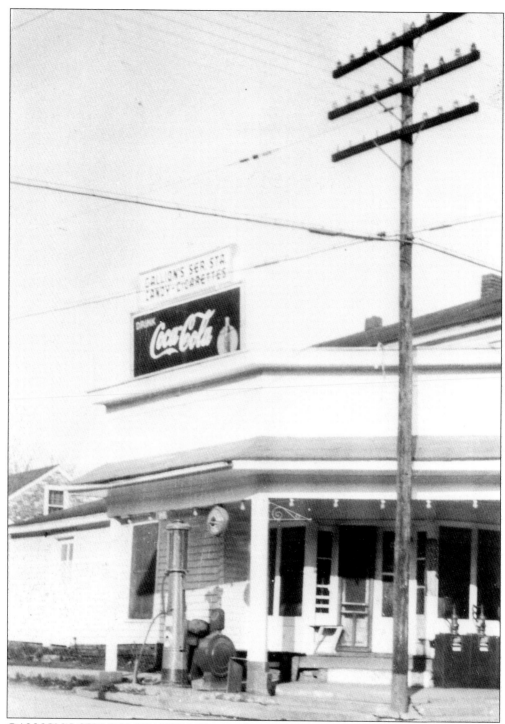

GALLION'S SERVICE STATION This is a later picture of Gallion's Service Station. By the time this photograph was taken, the Talley house—the brick residence in the left-hand corner—had replaced Liberty Hall. In the 1950s, Gallion's sold Amoco gas, and its upstairs rooms were used as the town hall. (Talley)

Four
Businesses

THE TALLEY BUILDING The Talley Building was used as a movie theatre from 1937 to 1952 called Talley's Indoor Theatre. Before "talkies" arrived in Louisa, silent movies were shown by W.W. Smith at this location. This site was also home to other businesses, such as a general store run by Flannagan and Talley, and to a 5¢ and 10¢ store run by F.Q. Thompson. Today the Jefferson National Bank is on this site. (Talley)

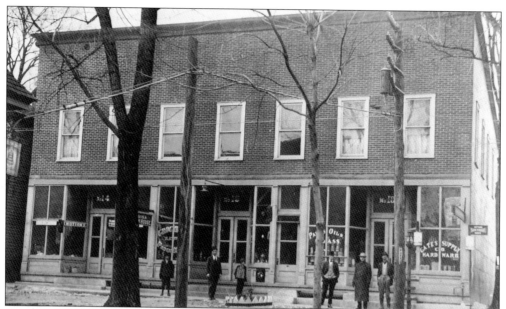

GATES BUILDING The old Gates Building held the Gates Supply Co. Hardware Store, the Louisa Bargain House, and a grocery store. Charles Gates built the building about 1909. Upstairs there were rooms for rent. The Gates Building was destroyed by fire on September 19, 1954. It took four hours to put out the fire. (LCHS)

SMITH-VAUGHAN HOUSE The Smith-Vaughan House was once used by Dr. Walton O. Smith as a dentist's office. It was later occupied by the family of Horace Lee Vaughan, whose son, Dr. Henry T. Vaughan, had his dentist's office in the house. Its final use was as the Louisa Hospital, a private hospital formed by Dr. Holmes G. Byrd. The property was demolished in 1969 to make way for a parking lot for the new post office. The building stood between Beeler's Appliance Store and the property owned by Mrs. Rosabelle H. Flaherty on Main Street. (LCHS)

MAIN STREET, LOUISA It is believed that these ladies are sitting in the yard of the Louisa Hotel with the south side of Main Street in the background. The building behind them is an early frame building which was typical of the early store buildings. C.E. Harris, a carriage shop owner in Louisa, advertised his services with these words: ". . . repair of Wagons and Buggies, Horseshoeing, Plates for cutting threads of all sizes, Machine for upsetting tire instead of cutting. Can do any work promptly, satisfactorily and at fair prices. Bicycles repaired." (LCHS)

WINSTON LAW OFFICE Frank V. Winston's law office was in a little brick building on South Main Street. The building later housed Dr. Porter's office, until the Louisa Drug Store began, at which point it was sold to H. Manning Woodward. Today the Woodward Building occupies the site. (LCHS)

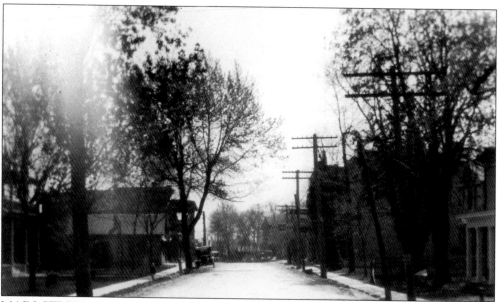

MAIN STREET, LOUISA In this 1937 picture taken looking east up Main Street from the present location of Meadow Avenue, the first building on the right is Mrs. Rosabelle Hunter Flaherty's house. Rosabelle Hunter Flaherty was town clerk for many years. Next to that is Dr. Vaughan's. The brick building is the Dobbins Building, which still stands today. It was built on a portion of the "old Dragon" lot and was used in earlier years as a post office and a C&P Telephone office. The Chevrolet dealership is next, and the Methodist church is in the distance. The Louisa Hotel is the first building on the left. (LCHS)

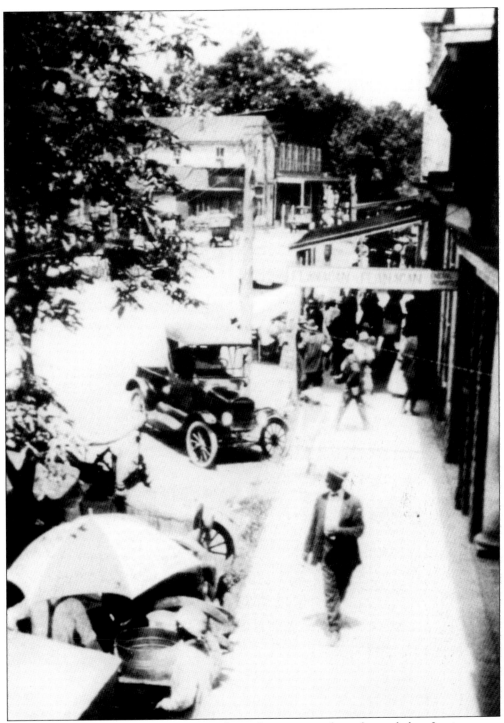

MAIN STREET, LOUISA This picture shows the street vendors who traded on Louisa streets even before it became a town. Vendors often set up beside the depot to meet passengers getting on or off the train. Their business generated many taxes for the town. Flannagan and Flannagan was a dry goods store. (LCHS)

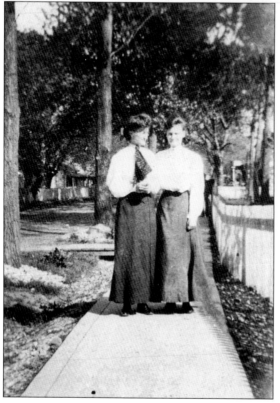

JEFFERSON HIGHWAY This 1926 photograph of the first paved highway through the town of Louisa was taken looking east from what was then the town line on the way to Gordonsville. The movie theater and dance hall operated by John P. Bibb can be seen on the left, and the home of H.Q. Dickinson (now Wharton) is on the right. The small building just below the H.Q. Dickinson home was a plumbing shop at the time. To the right of that is the home of A.G. Dickinson (later Bickley), and to the left of the A.G. Dickinson home is the First Baptist Church and the courthouse. The cement highway was 16 feet wide at this time. (LCHS)

STREET SCENE This photograph of two young women walking down the street in Louisa illustrates the country feel of the old town. Tree-lined residential streets blend into the shops and stores a mere block away. (LCHS)

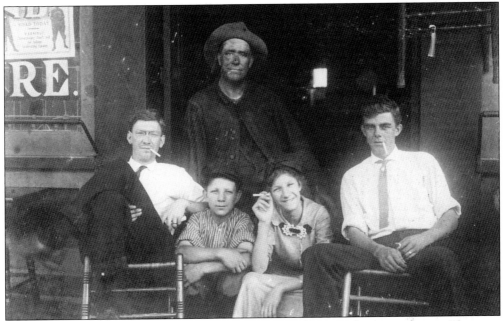

TEEN GATHERING This gathering could have taken place anywhere, at any time. The teens are, from left to right: unknown, H. Manning Woodward, Carolease Woodward, and Brownie Flannagan. The gentleman in the doorway could not be identified. (LCHS)

LOCAL CITIZENS Harry Wilson Porter, Barton Porter, and Helen and Bruce V. Boxley pose for a snapshot taken in Louisa. The Porters and the Boxleys lived on Ellisville Road. (Boxley)

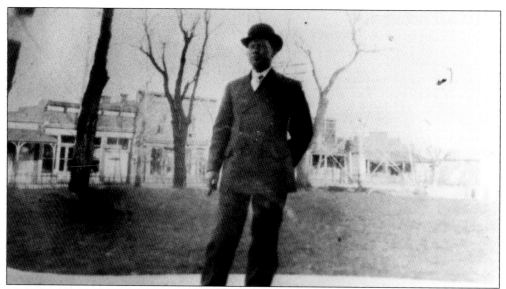

NORTH SIDE OF MAIN STREET Willie C. Wright, a postal clerk around 1910, stands on the courthouse lawn. This picture shows the general appearance of the north side of Main Street in the early twentieth century. (LCHS)

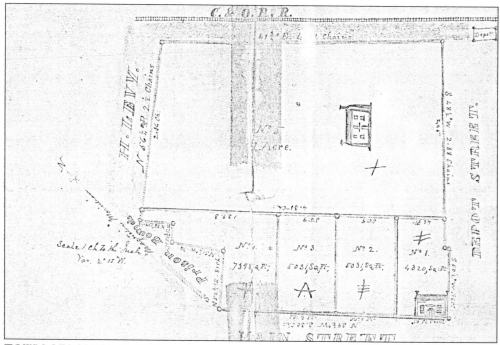

TOWN OF LOUISA PLAT This plat shows the land that was sold to Dr. Edmund P. Goodwin by J.M. Bickers. Historical records indicate that by August 18, 1868, Edmund P. Goodwin was in the process of building a home for his wife, Lucy A. Goodwin, at Louisa Courthouse. His wife became the postmistress for Louisa and served, on and off, from 1877 to 1897. In a suit, Quarles vs. Goodwin, the part of this property facing Main Street was sold to individual businessmen. This transaction represents the real beginnings of the town. It is also interesting to note the old prison boundaries on this plat. (Clerk)

WILLIAM H. YOUNG William Young was one of the businessmen who bought portions of the Goodwin land. Mr. Young was a manufacturer of tin and sheet ironwear and a dealer in lamp goods and stoves. He was also a member of the 56th Virginia CSA and the Masonic Lodge. Mr. Young died on January 8, 1892. The other businessmen who bought land were W.O. Thomas, W.S. Gooch, James M. Bickers, and Mr. G. Smith. (LCHS)

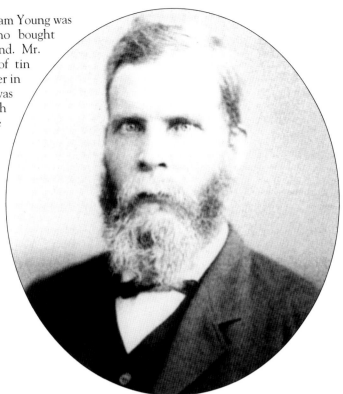

BEALE STORE The F.M. (Polly) Beale Store is shown in a c. 1920 photograph. After renting it for several years, in 1909 Mr. F.M. (Polly) Beale purchased this store. For many local people, memories of this store conjure up memories of a time when chickens were delivered live and cheese cut from a wheel. Today, the store is an Ace Hardware Store. (LCHS)

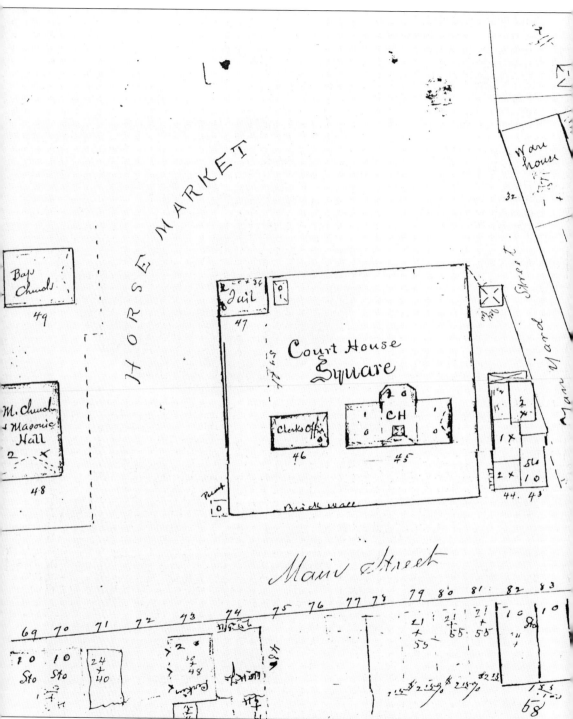

MAP OF LOUISA IN 1888 On January 8, 1888, a fire destroyed most of Louisa's business district. Because the majority of the buildings were wooden, and because there was no fire company, the fire wreaked havoc on the town. Records show that the dry goods establishment of Flannagan & Flannagan, the confectionery store of W.A. Bonavita, and Woodward and

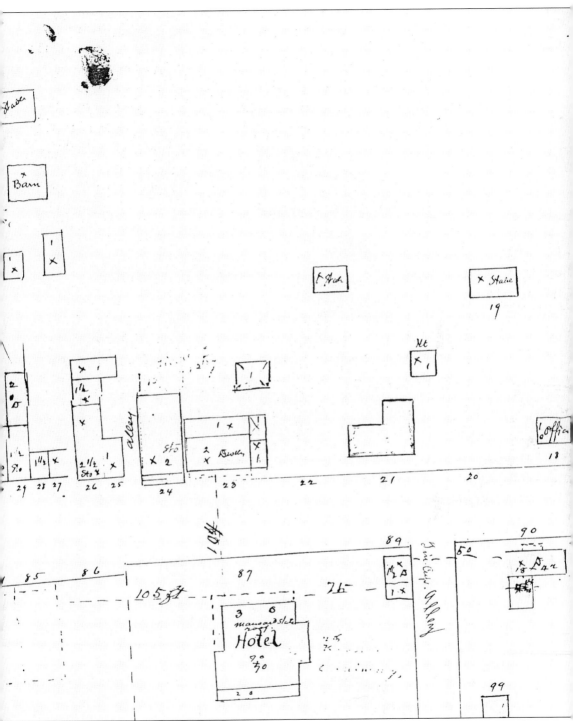

Kennon's furniture were the only businesses spared by the merciless flames The new hotel, however, was saved. New building codes were established in 1888 to prevent similar disasters. (LCHS)

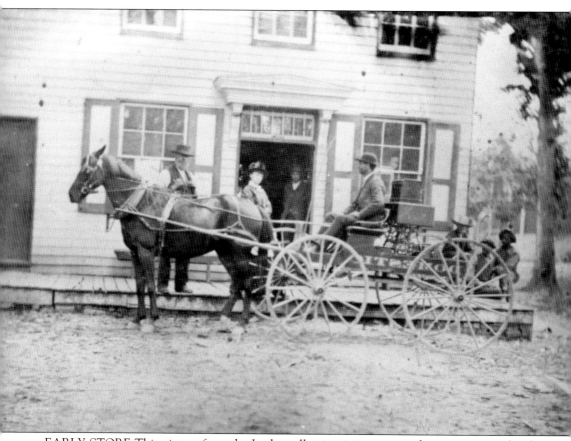

EARLY STORE This picture from the Leake collection is interesting documentation of early commerce. It shows an old store front, probably in Louisa. The sign on the side panel of the wagon reads Domestics. (LCHS)

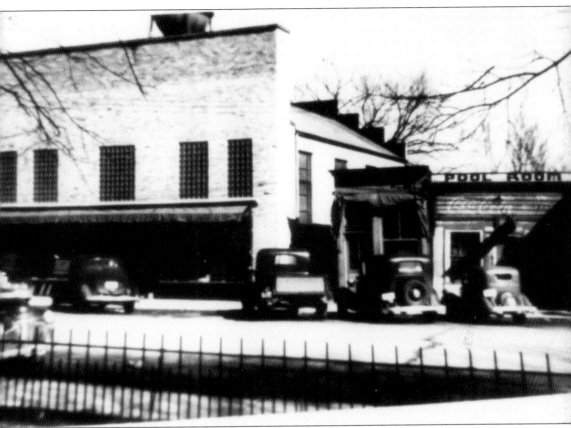

NORTH SIDE OF MAIN STREET, LOUISA Completed in 1946, the Jefferson Shop (left) was built on the site of an earlier building that housed a bank and the town hall (above the bank). Today the building is the Jefferson Professional Building. The building next door (center) was once the Cunningham Jewelry Store, and later a pool room. It was subsequently bought by People's National Bank and today it houses a branch of Nation's Bank. The J.R. Maddox Store is the last building in the row. (LCHS)

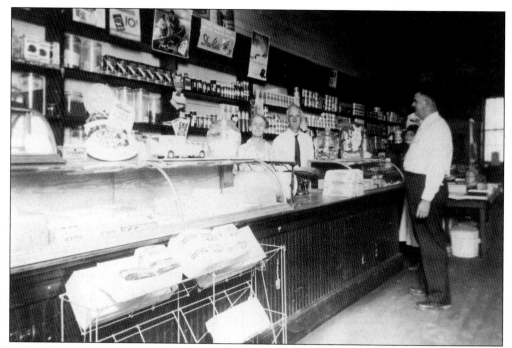

HESTER STORE INTERIOR This 1930 photograph of Mr. and Mrs. Charles Ellis Hester's Store in Louisa gives us an idea of a typical store interior of that time. Charles Ellis Hester inherited the business from his bachelor uncles C.N. and R.J. Hester. C.N. Hester advertised as early as 1890 that the store sold confectionery, tobacco, cigars, stationery, canned goods, lemons, raisins, figs, dates, sugar, coffee, as well as ice cream in season. (LCHS)

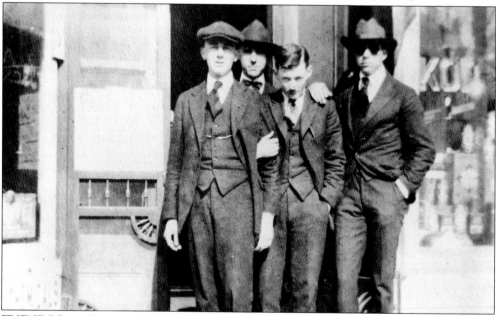

FRIENDS Percy Bates and Bruce Boxley with John Q. Rhodes in back and an unknown friend to the left in front of a drug store in Louisa. These gentlemen were prominent in the town and in Louisa County. (LCHS)

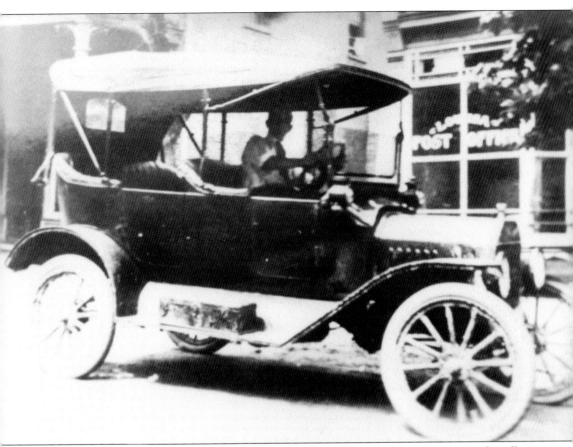

POST OFFICE This 1916 snapshot of the post office shows its location next to the alley between the Boxley Building and what is today the Wright-Loving Furniture and Appliances Store. Charles Allen Hunt is in the 1916 Ford. The photograph was taken by Mrs. Martha Allen Hunt Dobbins. (LCHS)

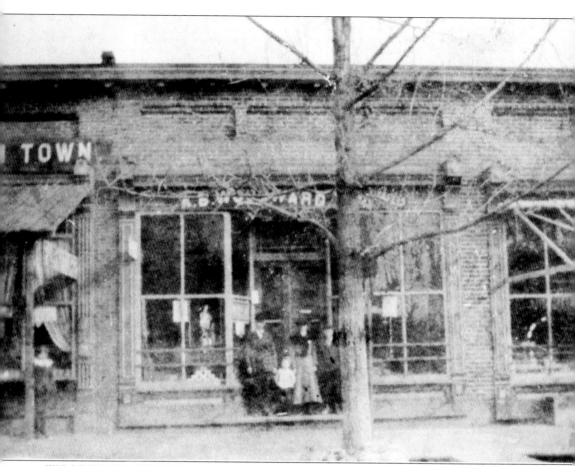

WOODWARD FURNITURE AND FUNERAL BUSINESS A.B. Woodward placed the following advertisement in the *Louisa News* in 1898: "Funeral Director conducts the Undertaking Business at his old stand on Main Street, Louisa Va. All orders for Coffins, Caskets, etc. from the county or abroad promptly and satisfactorily attended to either at night or day. No charge for attending Funerals." Andrew Broaddus Woodward founded the business in 1884. He also ran a furniture store with Mr. Kennon. (LCHS)

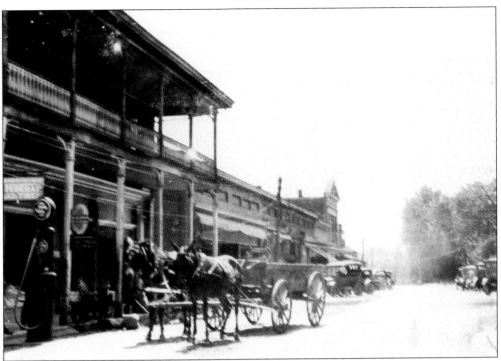

BOXLEY BUILDING The Boxley Building when it had a double porch. Dr. H.S. Daniel had his office in the upstairs of the Boxley Building at one time. The building was also home to the Louisa Hardware and Motor Co. and the Virginia Public Service Light Company. (LCHS)

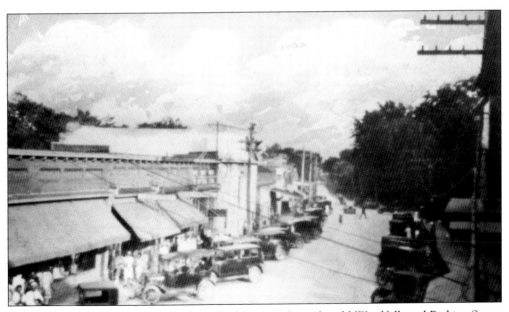

MAIN STREET A view of Main Street looking east from the old Woolfolk and Perkins Store, which was once the Levy property and later the Woolfolk's Louisa Department Store. It is now the Wright-Loving Furniture and Appliances Store. The Levy property included all four stores up to the tall, white building which is now the Jefferson Professional Building. (LCHS)

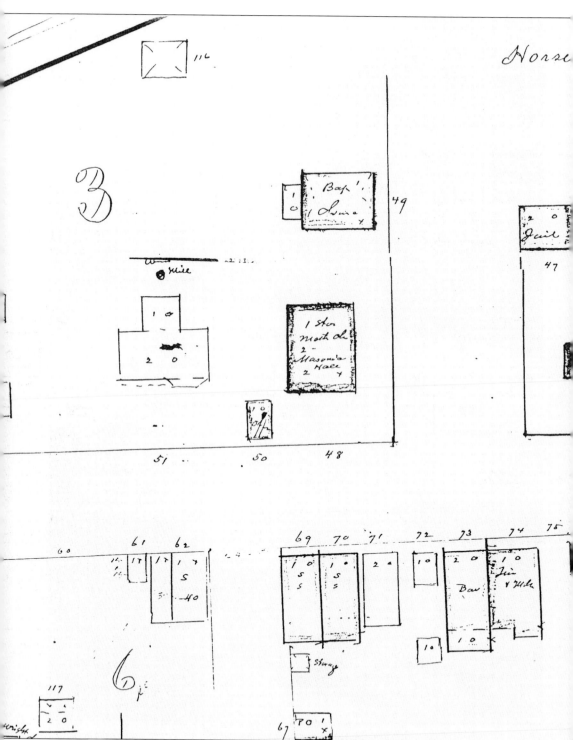

MAP OF LOUISA IN 1896 By October 1896, eight years after the devastating fire, the town of Louisa was once again thriving. The businesses shown on the map are: a bar, a tin and merchandise store, stables, a drug store, a meat shop, a confectionery shop, a furniture store, a

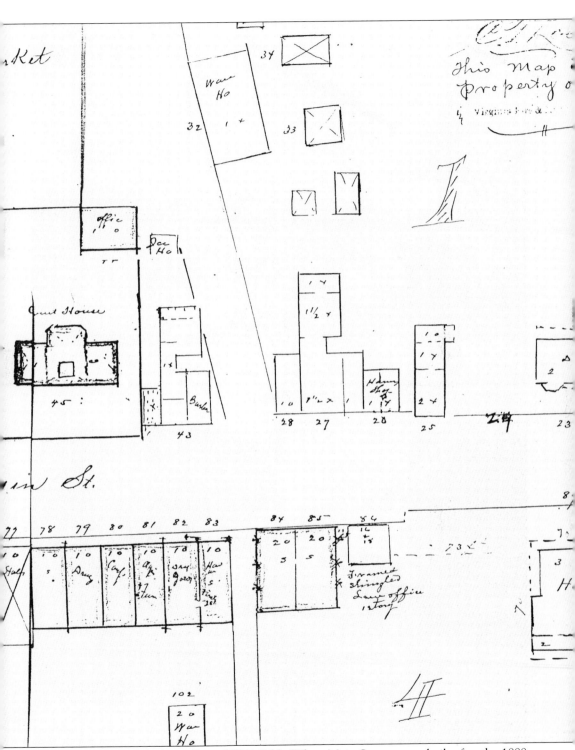

dry goods store, and the law office of W.E. Bibb. When Main Street was rebuilt after the 1888 fire, most buildings were constructed of brick: only a few business owners did not heed the lesson of the fire. (LCHS)

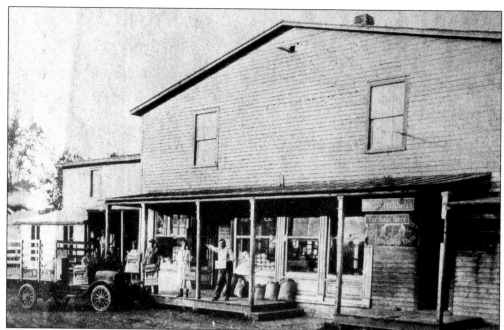

VIRGINIA FEED AND SEED COMPANY The central part of the Virginia Feed and Seed Company building was moved from Main Street to this location near the depot by 1917. Mr. E.S. Hanson operated the company. This 1927 picture includes E.S. Hanson, Mrs. Wright, Mr. Sherwood Leake, Pat Trice, and Hale Hanson. (CV)

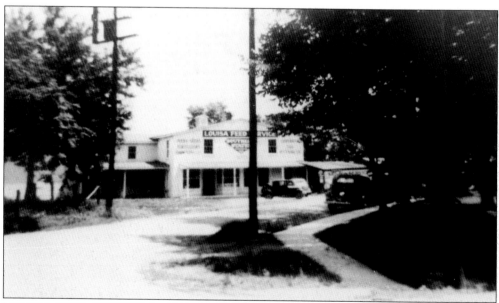

LOUISA FEED SERVICE In 1943 Mr. A.C. Marshall bought the Virginia Feed and Seed Company and renamed it the Louisa Feed Service. He operated the business for some years until he moved the company to a new location on Route 22. Louisa Brass Beds occupied the building for a short time. It was also used for entertainment purposes during a revival of March Court Days. The long-vacant seed company building was torn down in the summer of 1996. (Boxley)

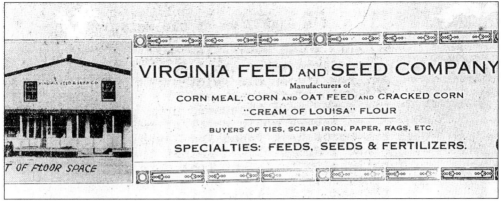

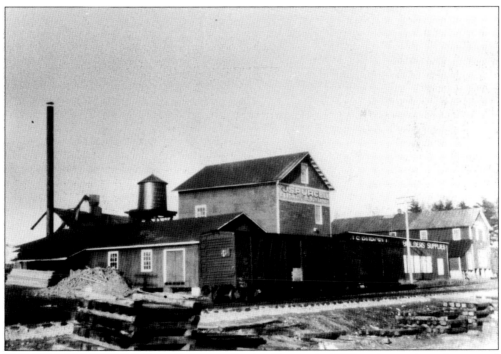

LOUISA FEED SERVICE ADVERTISEMENT This advertisement for the Louisa Feed Service presents the many services available at the store. Maddox Feed is located in the same area today, and it offers the same type of services. (LCHS)

PURCELL LUMBER J.S. Purcell came to Louisa County in 1903 and went into the general merchandise business. He established a wholesale lumber business in 1916. The Purcell Lumber building burned down in 1948, but was later rebuilt. The business is run today by John Jerl Purcell as the J.S. Purcell Lumber Corporation. (LCHS)

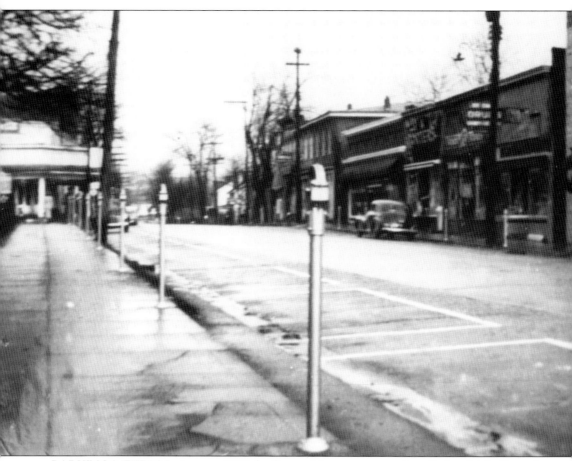

PARKING METERS In January 1949 the first parking meters were installed on Main Street in Louisa. The limited use of the meters shows that people were not enthusiastic about this change. (Gilmer)

Five

Residences

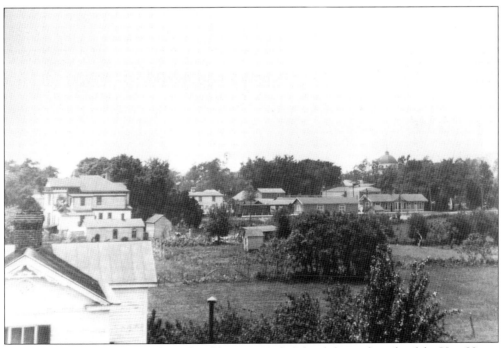

BIRDSEYE VIEW This view from the old Louisa High School shows the side of the Hart House on School Street, the back of the funeral home, and the C&O freight station and depot. The windmill can be seen on the skyline behind the Methodist church and the courthouse dome. (LCHS)

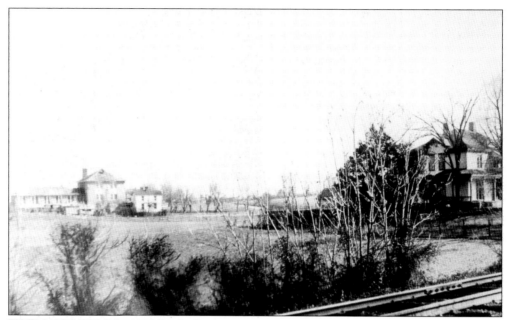

FIREMAN'S FIELD In 1935/36 the Porter property was a 7-acre tract. The grounds were sold to the Louisa Volunteer Firemen in 1938 to be used as a fairground and the land has been used for that purpose ever since. (Gilmer)

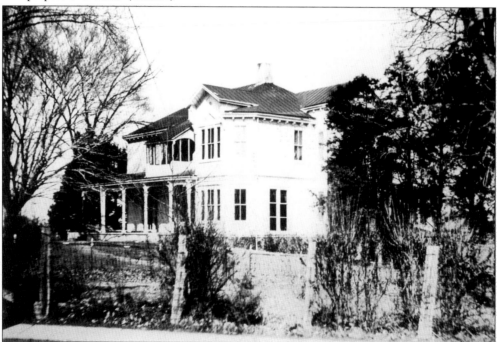

PORTER HOUSE Josephine Norris Porter bought the Porter property on July 6, 1901. There Dr. Harry W. Porter and his wife resided and worked for three decades until the doctor's sudden death in 1934. Mrs. Josephine Porter is remembered for her piano lessons and as an organist. The house was sold to Manning H. Woodward by Josephine N. Porter in 1936. It has been used since that time as a funeral home. (Gilmer)

DR. PORTER Dr. Harry W. Porter and Dorothy D. Boxley, his great-niece, posed for a photographer c. 1935. Dorothy was the daughter of Taylor M. Boxley and Mildred Porter. This picture was taken in front of the Louisa Drug Co. which was located in the Old Farmers and Merchants Bank Building. (LCHS)

SARGEANT HOUSE The J.F. Sargeant House is located near Louisa High School on Fredericksburg Avenue. It has been occupied by W.A.C. Pettit Jr., since 1926. (LCHS)

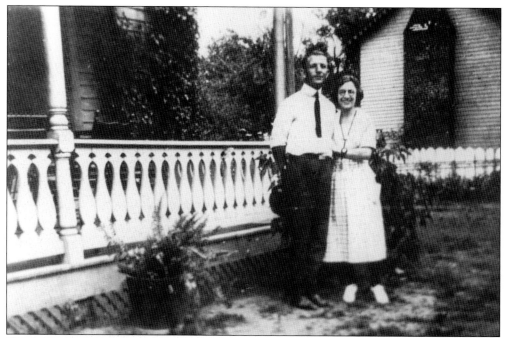

WOODWARD CHILDREN H. Manning and Rosa Woodward, the children of A.B. Woodward, stand beside their home. The Massie House can be seen in the background. H. Manning Woodward joined his father in the family business in 1918. (LCHS)

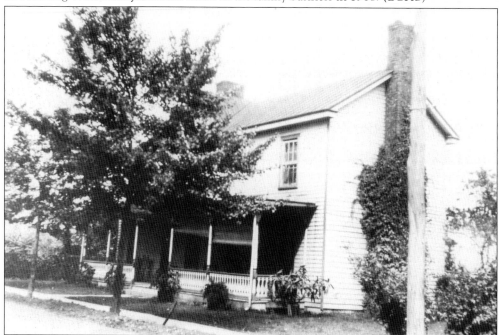

WOODWARD HOUSE The A.B. Woodward House around 1925. It was demolished to make room for a parking lot. It is now the location of the Mini Mart. Andrew Broaddus Woodward (1852–1918) founded the Woodward Funeral Home in 1884 and the business remained in the family for many years. (LCHS)

MASSIE HOUSE The Massie House was owned by Mrs. Lavinia Winston Massie, who reared Porter Wright. It was demolished in 1988 to make way for a parking lot and a business. James Hackett lived in this house in the 1880s. In the 1890s Ada Flannagan moved into the house, and ran a switchboard for the telephone company from it. When Mrs. Flannagan moved to Elm Avenue so did the switchboard. (LCHS)

LAVINIA MASSIE Lavinia Winston Massie is shown in her front yard at the corner of Main Street and Cutler Avenue. Cutler Avenue has been called Tin Cup Alley and Parson's Row in years gone by. Mike's Glass and Mirror Company now occupies this site. (LCHS)

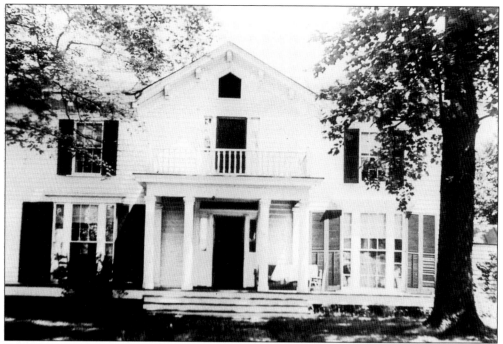

INGLESIDE Mrs. Charles Donnally's home was large, so she often took in summer boarders. Mrs. Donnally also ran a school in her home. The site is now the location of Donnally Dale. (Gilmer)

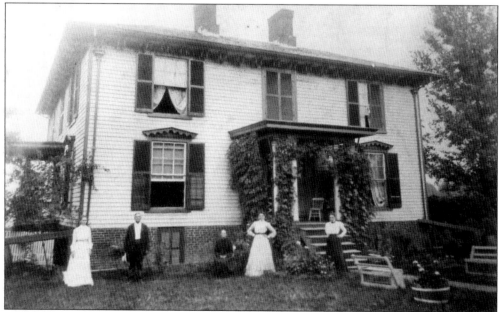

SMITH HOUSE The Smith House, built *c.* 1860, was originally a frame house which was later enclosed in brick by the Boxley family in 1918. Standing in the front are Miss Smith, Dr. W.O. Smith, his mother (Mrs. Mary Walton Smith), and Kane Smith Dowell. Dr. Edwin L. Smith, the husband of Mary Walton Smith, was a dentist in Louisa County. He built his home across the road from his father-in-law, William Walton. (LCHS)

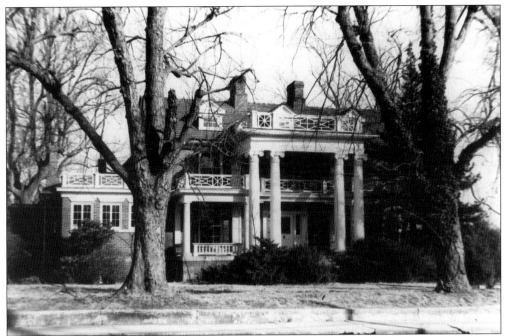

BOXLEY HOUSE In 1918 architect D. Wiley Anderson remodeled the Smith House for the Boxley family. The renovations included: the addition of a dining room, a kitchen, and a bathroom; the replacement of the slate roof with terra cotta tiles; the bricking in of the entire building; and the addition of Ionic columns. D. Wiley Anderson was also the architect for the Louisa County Courthouse. (LCHS)

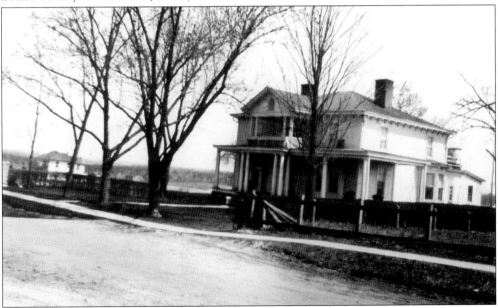

CHAPPELL HOUSE The Chappell House was originally owned by P.B. Porter, for years the clerk of Louisa Court. It is located at the intersection of Ellisville Drive and West Street. This picture was taken in 1926 when there were no near neighbors. The Chappell House is owned today by the Garnett family. (LCHS)

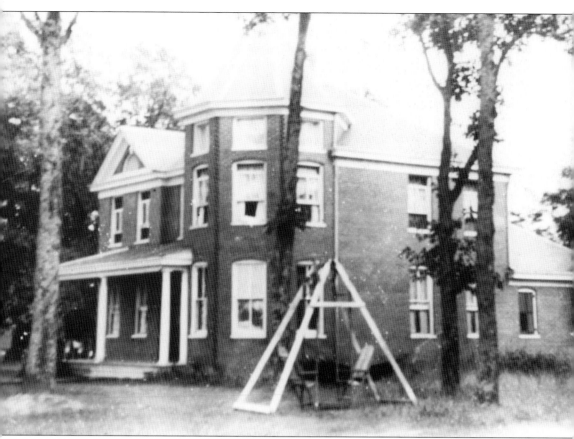

MAY HOUSE In 1905 Mrs. Martha Gordon sold to John Goodwin and Ione C. May the land on which they would build their home. At the time they built there were only four other houses in that section of town. It is now a lovely residential area. The house is owned today by the Cullen family. (LCHS)

GLASCO HOUSE Gladys, John, Cutler, and Janie May stand in the yard of the May House with the Glasco House in the background. Once owned by Weir Goodwin and Joseph B. Winston, the house stands on a site that some believe was once occupied by the old Walton Tavern. This part of town, around West Street, was called "the Grove" for many years. (LCHS)

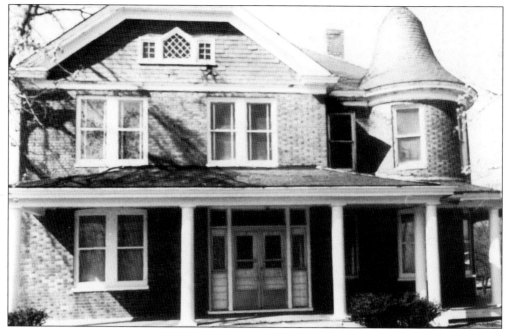

HADDER HOUSE The Hadder House was built c. 1911. It was built by the Leigh brothers, as were so many of the finer houses of Louisa. H.Q. Dickinson was the first owner to be associated with the house. It is now owned by the Wharton family and run as The Whistle Stop bed and breakfast. (Hadder)

MR. AND MRS. HUGH DICKINSON Hugh Q. Dickinson and Mary Hawes, his wife, also owned the Louisa Hotel. It was under their ownership that the "restrictions" begun in 1818 on landowners in the town of Louisa were discontinued. A 1904 deed, which included every landowner in the town, stated that Dickinson had the ". . . right to grant, convey & release and forever extinguish the said, 'restrictions' on the sale of liquor. . ." (Hadder)

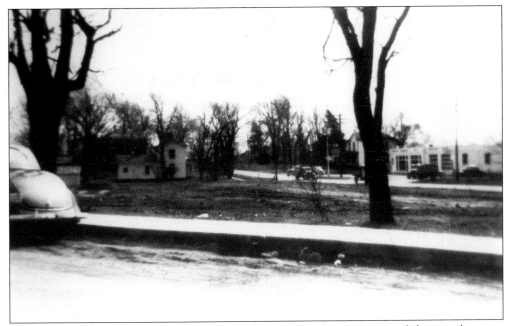

FREDERICKSBURG AVENUE AND MAIN STREET This is a view of the area between Fredericksburg Avenue and Main Street where Ferebee Ford now operates. The Baptist parsonage was gone by 1944 to make room for J.B. Hadder's Louisa Motor Company, which sold Fords. Note Phil Vaughan's house in the distance across from Petitt Motors. (Gilmer)

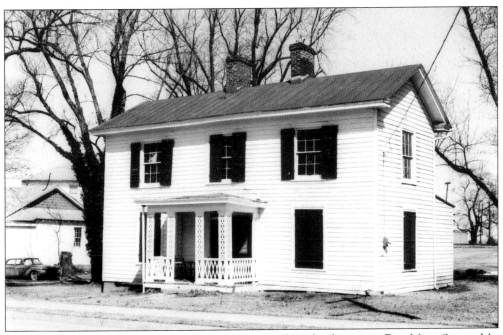

VAUGHAN HOUSE Philip Newton Vaughan lived in this house on East Main Street. Mr. Vaughan was originally from Spotsylvania County. While living in Louisa, he was a partner with H. Manning Woodward at a Chevrolet agency. The house was torn down to make room for the sale of recreational vehicles. (LCHS)

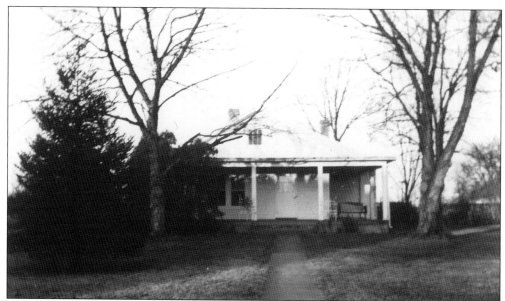

WRIGHT HOUSE The Porter Wright House became the Louisa Flower Shop in 1989. It was originally the home of Porter and Helen Wright. Porter Wright was a local historian, a banker with the National Bank and Trust Company, and a town mayor. The Louisa Flower Shop is run by Jay Perkins. (LCHS)

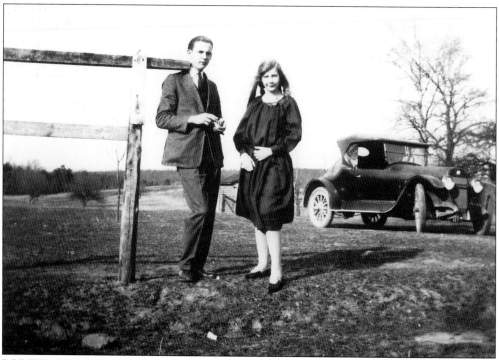

PORTER WRIGHT Porter Clay Wright poses here with Enma Boyd in front of what looks like a 1920 Buick Roadster. His work with the Louisa County Historical Society helped to create a museum for the preservation of Louisa County history. Wright was also an amateur photographer, and his work is a valuable record of many people and places in the town and county. (LCHS)

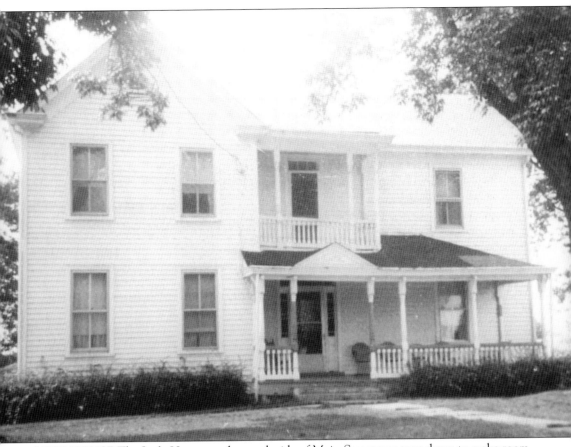

LYDE HOUSE The Lyde House on the south side of Main Street was torn down to make room for the new Louisa Volunteer Fire Department in 1989. The house was owned originally by R.H. Lyde. It was willed to Hugh F. and Cora F. Lyde in 1915. It was sold to Walter S. Hoye, a Christian preacher, in 1929, and later owned by Roger L. and Mattie D. Kincannon. (LCHS)

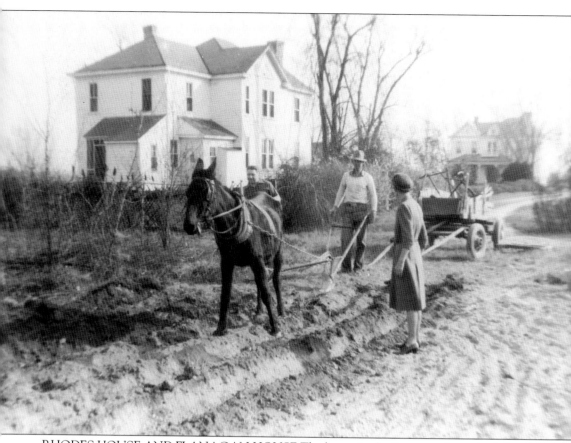

RHODES HOUSE AND FLANAGAN HOUSE The house in the foreground was the John O. Rhodes House from 1923 to 1959. Across the road is the H. Manning Woodward Sr. House, also known as the C.D. Flanagan House. The feeling of space in this area of town very much belongs to another time. This picture was probably taken in the 1940s. (LCHS)

CRANK HOUSE William James Crank and his wife Eloise Miller Crank were the parents of W. Earle Crank, Lois Crank, and Mrs. Erving Everett. Eloise Crank's home was a gathering place for family and friends, many of whom enjoyed her gracious hospitality for protracted periods. The house was called Pleasant View. (LCHS)

HELVIN HOUSE The John G. Helvin House is located on the north side of Main Street next to the McKenny House. John Helvin was a master blacksmith who had his shop near the depot. Originally from Maryland, he moved to Louisa in 1923, and died in 1954. His wife was Addie Quisenberry Meadows Helvin. The house was later taken over by C.J.C. Smith. (Gilmer)

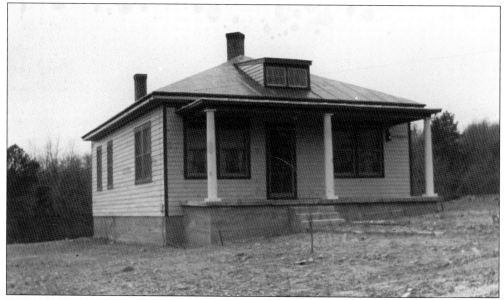

WESTOVER HOUSE This Westover subdivision house was one of a group of similar craftsman-style houses built on adjoining plots. The subdivision was begun in 1914 by George V. Venable and Kiah T. Ford after they bought 29 3/4 acres from Kate C. Bibb. The land was divided into streets, lots, and alleys in accordance with a plat made by C.L. DeMott. All houses were to be built 60 feet from the road. (LCHS)

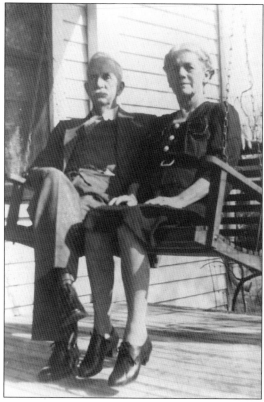

MR. AND MRS. HESTER Charles E. and America Gooch Hester in the swing at their home in Westover. Charles Hester bought lot 31 in Westover on April 14, 1914. (LCHS)

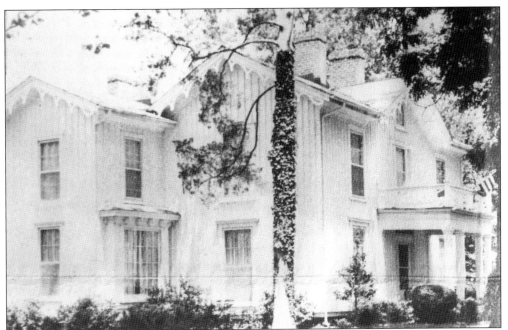

GABLE MANOR This house, located at the corner of Elm Avenue and McDonald Street, was possibly built by Judge Ed H. Lane. Once called Rose Cottage, it was re-christened Gable Manor by Mrs. R. Heber Richards. Gable Manor is a fine example of Gothic Revival design, a style influenced by the writings of Andrew Jackson Downing. The house is now owned by Jill Probst. (CV)

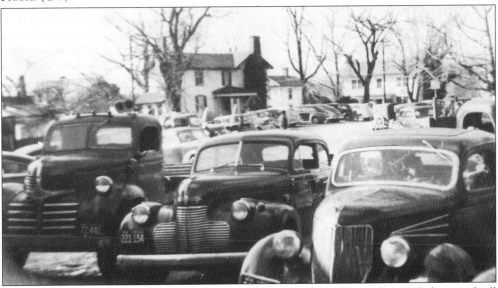

FLANAGAN HOUSE The Flanagan House, now a law office, was nearly crowded out with all the cars on January 22, 1949. Parking meters had been introduced on Main Street, so it was "first come, first served" in the back of the courthouse, where no meters lurked. Parking at a meter meant spending 5¢ for 60 minutes, or 1¢ for 12 minutes. One man insisted "the town had no right," and he was not so far wrong since the road is part of the 2-acre public square, bought in 1818. (Gilmer)

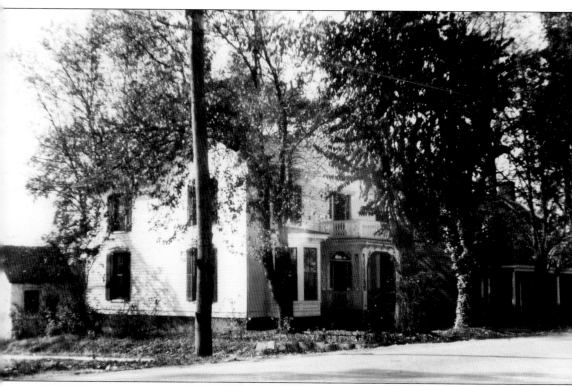

TALLEY HOUSE The Talley House was once located on the south side of Main, where a temporary clerk's office has been set up. The house was dismantled to make way for the old Safeway parking lot. It was occupied at various times by the Talley family, the Overton family, the Ellis family, and the Porter family. (LCHS)

Six
Churches, Schools, and Fire Departments

ST. JAMES EPISCOPAL CHURCH Compton Thomas stands with Jack and Rody (the mules) at St. James Episcopal Church. St. James was finished in July 1881 after the congregation struggled for many years to build their own church. It was due mainly to the efforts of the Reverend James Grammar that the church was completed. On February 2, 1991, one hundred years after the church was completed, St. James officially received full church status under the leadership of the Reverend John von Hemert. (LCHS)

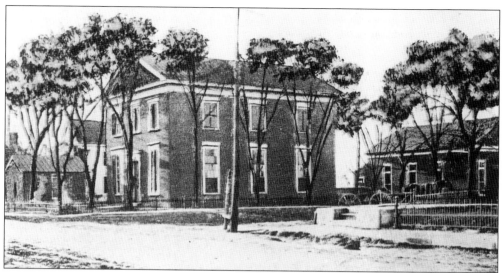

BAPTIST AND METHODIST CHURCHES This early view of the Louisa Methodist Church (in the foreground), and the Louisa Baptist Church (to the right), shows them before renovations or additions. Next to the Methodist church is a little brick building which was Captain Murray's law office and later Judge Sims' office. The house beside the law office was Judge Sims' home, which was demolished in 1959. (LCHS)

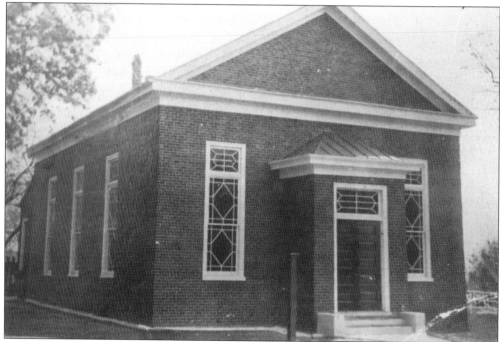

MEMORIAL BAPTIST CHURCH Before it was remodeled, the Memorial Baptist Church had a simple form. One of the oldest churches in Louisa, it was planned in 1849 and called the Upper Gold-Mine Baptist Church. The building was used by the Louisa Baptist Church until 1966. On September 1, 1968, after the congregation of the Louisa Baptist Church moved to another building, the Memorial Baptist Church was organized, and it continues to worship in the building today. (LCHS)

LOUISA BAPTIST CHURCH PARSONAGE The Louisa Baptist Church parsonage is located on East Main Street, next door to the church. The church, first known as the Upper Gold-Mine Baptist Church, was constituted in 1829. The congregation built what is now the Memorial Baptist Church building around 1849. In 1885 the church's name was changed to the Louisa Baptist Church. In 1968, when the congregation had outgrown its original building, it moved to the new building on East Main Street. (LCHS)

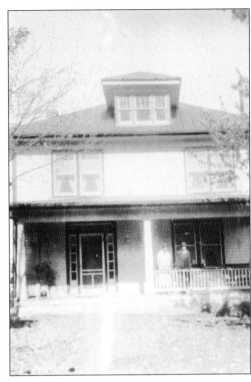

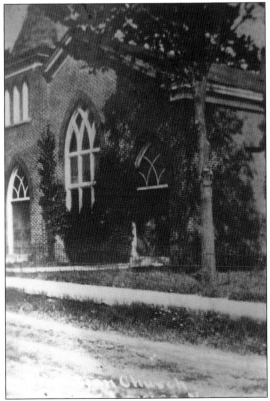

LOUISA CHRISTIAN CHURCH The Louisa Christian Church was organized in 1851 with twelve charter members. In the early years they were called the "Reformers" or "Disciples of Christ" and they convened under the leadership of James W. Goss. In 1905 the vestibule and gallery were added to the church. More work on the building was done in 1957 and a new addition was built in 1967. (LCHS)

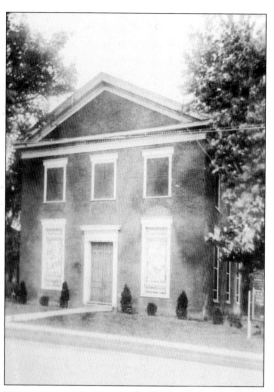

LOUISA METHODIST CHURCH The Methodist church was built in 1852 in a joint venture of the Methodist, Episcopal, and Masonic Day Lodge # 58 A.F. & A.M. trustees. The Methodists met downstairs and the Masons upstairs. The Episcopal members were allowed to meet one Sunday a month. By 1859 the church had 491 white members and 48 black members. The church was used as a hospital during the War Between the States. (LCHS)

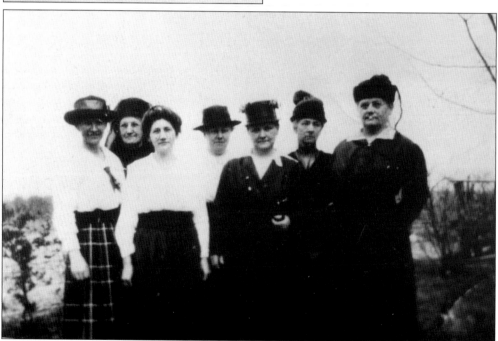

LADIES AID SOCIETY Included in this photograph of the Methodist Church Ladies Aid Society are, from left to right: Miss Carolease Woodward, unknown, Mrs. H.W. Wright, Mrs. J.K. Deane Sr. (Mabel Woodward), Mrs. C.D. Flanagan (Mamie Woodward), Mrs. Walter Perkins, and Mrs. J.R. Maddox (Etta Woodward). (LCHS)

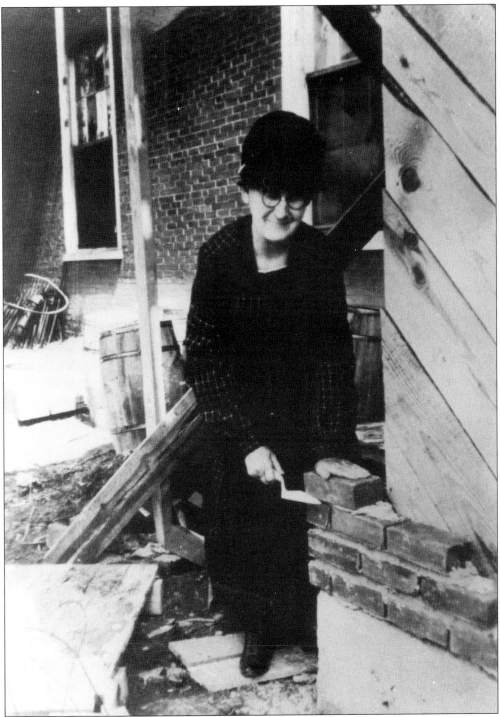

METHODIST CHURCH ADDITION Mrs. Nora B. Woodward, the oldest member of the congregation at the time, placed one of the first bricks in the 1927 addition to the Methodist church. (LCHS)

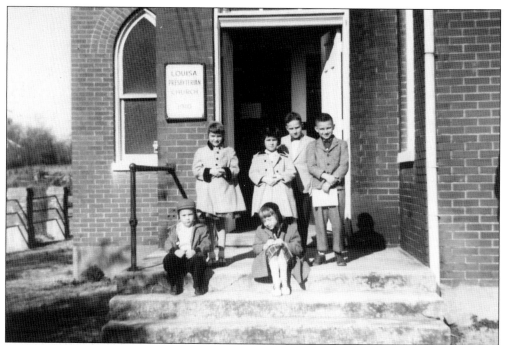

LOUISA PRESBYTERIAN CHURCH In 1909 members of the Wills Memorial Presbyterian Church withdrew and organized the Louisa Presbyterian Church with thirteen charter members. Mr. Charles W. Donnally donated the land on Depot Street (now Church Avenue) on which the church would be built. The building was completed by the spring of 1911. An addition was built in 1949 and dedicated in August of that year. This photograph shows young members of the Marshall family on the front step of the church at Easter. (Marshall)

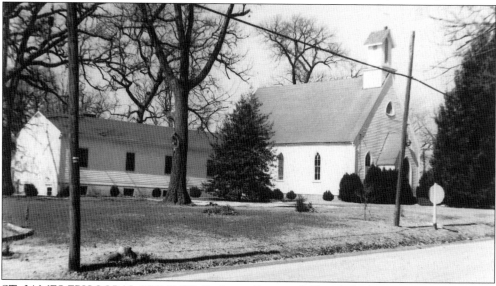

ST. JAMES EPISCOPAL CHURCH St. James Episcopal Church had several additions made over the years. In 1938 the chancel was enlarged by extending it into the nave. Later, rooms were added on each side of the chancel. The parish house was built in 1961 and a new bell tower was added in 1968. (LCHS)

FIRST BAPTIST CHURCH In 1866 Reverend Fountain Perkins organized the First Baptist Church. The congregation gathered at the old Methodist church near the C & O Depot, which was being used as a harness shop until put into use as the temporary home of the First Baptists. Dr. David N. Vassar was pastor when the present church, a frame building, was completed in 1883. (Thomasson)

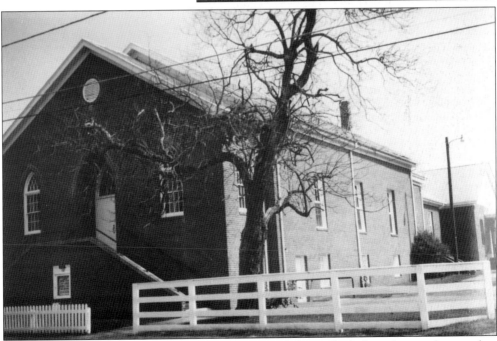

FIRST BAPTIST CHURCH The First Baptist Church has cathedral windows and a complete set of pulpit and communal furniture. The front of the building and the basement were remodeled and completely bricked in. (Thomasson)

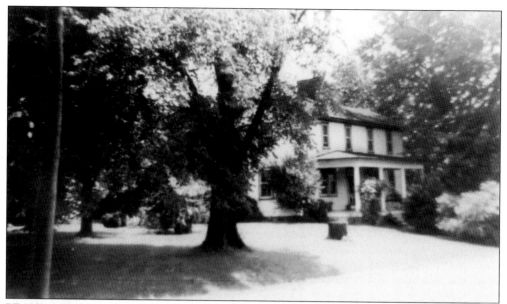

PEAKE SCHOOL At one time a Baptist parsonage stood where Ferebee Ford stands now, at the corner of Fredericksburg Avenue and Main Street. It is believed that before that, sometime in the nineteenth century, a school was run on the site by sisters Lucy and Ann Peake. Young people generally received their education in homes or in field schools before the organization of schools in 1870. (LCHS)

REVEREND LITTLEBERRY HALEY Reverend L.J. Haley was a Baptist minister and a member of the Virginia Legislature. He was named supervisor of schools under the new constitution in 1870. The first county-owned public school was named Haley High after him. He died on February 8, 1917. (LCHS)

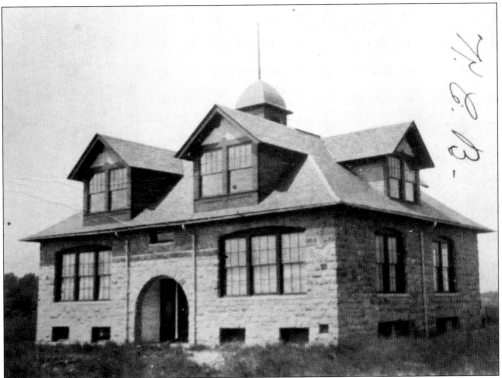

LOUISA HIGH SCHOOL Louisa High School was built in 1907 with state aid. This school took the place of Haley High on Elm Street. For years it was the only accredited high school in the county. Mineral and Apple Grove later had their own high schools. (LCHS)

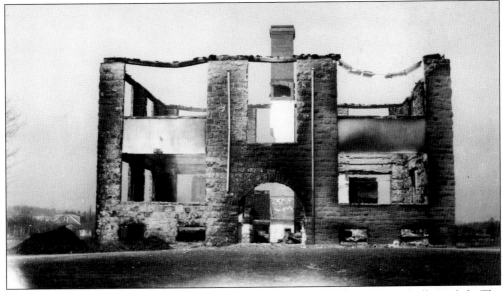

SCHOOL FIRE In February 1924 the Louisa High School burned; only a shell was left. The headlines in the paper read, "LOUISA SCHOOL PREY TO FLAMES" and "200 students march out safely as alarm sounds." The only part of the school that was saved was the auditorium. Erected in 1907, the high school was built of granite. (LCHS)

CLASS OF 1921 Included in this photograph of the graduating class of 1921 and members of the faculty are, from left to right: Nannie Elizabeth Woolfolk, Gay S. Donnaly (teacher),

William Lloyd Coppage, Marjorie Trice, John Lovell Smith, Evelyn Hester, W.N. Shepherd (principal), Annie M. Daniel, Varina Rhodes (teacher), and Hattie Payne. (LCHS)

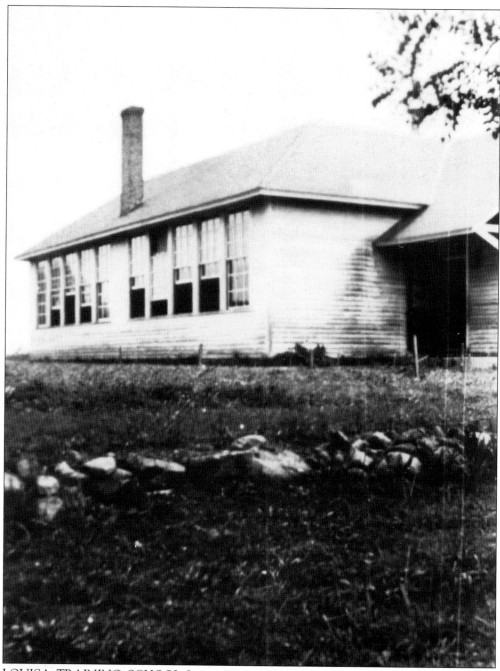

LOUISA TRAINING SCHOOL Louisa Training School was located where Thomasson's Funeral Home now stands. It was the first four-year high school for blacks. The school was in use until 1952. (Thomasson)

SCHOOL DESK In his thesis, *A Survey of Negro Education in Louisa County*, Paul Everett Behrens included this picture of the type of desk common in one-room schoolhouses. The desks were handmade, uncomfortable, and marred by long usage. This desk was at the Evergreen School in Louisa County. (LCHS)

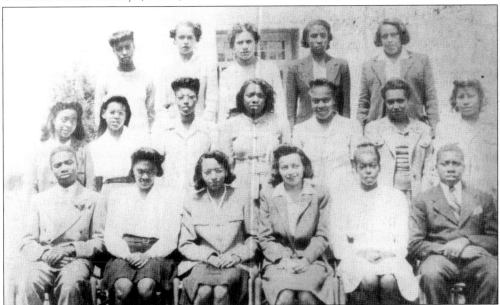

LOUISA TRAINING SCHOOL CLASS Included in this photograph of the class of 1946 at Louisa Training School are, from left to right: (first row) Carvie Mason, Jessie Gay Johnson, Portia Jackson, Mary Perkins, Mary Nelson, and Harry L. Nuchols; (second row) Alreatha West, Hortense Gordon, Joyce Robinson, Dorothy Thurston, Bertha Mosby, Sadie Johnson, and Alma Hughes; (third row) Iris Lewis, Pauline Jackson, Delores Morris, Daisy Jackson, and Mary Thompson. (CV)

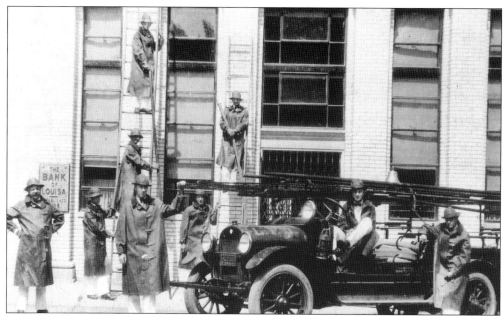

LOUISA FIRE DEPARTMENT This photograph of the Louisa Volunteer Fire Department was taken in 1927 by Porter Wright. The shot was set up at the Bank of Louisa as it was the tallest building in town and therefore the best place to display the department's ladders. Included in the picture are, from left to right: (back) Chief E.S. Hansen, Henry J. Woolfolk (holding the first ladder), John P. Bibb (on the bottom of the first ladder), E.L. Southard (on the top of the first ladder), Herbert Timberlake (holding the second ladder), Alfred Percy Gates (with the hose); (front) Charles Berkley Baughan (with his hand on the ladder) and John K. (Freddie) Deane Jr. (the driver). In the rear is John Wesley Wright Jr. The fire department's first fire truck was a Reo. (LCHS)

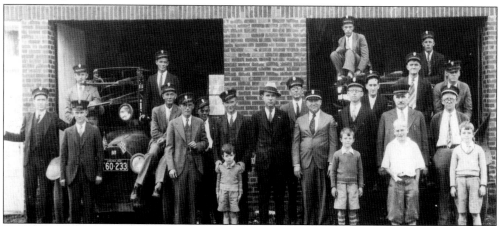

LOUISA FIRE DEPARTMENT Included in this photograph of the fire department in front of the Louisa Fire Department Building at the courthouse are, from left to right: (standing) William Cooke, Percy Gates, William E. Lynch, Allen W. Flannagan, Robert Kent Woolfolk, John O. Rhodes, Samuel Henson, Otis Rupert Thompson, Henry J. Woolfolk, Richard E. Perkins, and Elijah L. Southard; (sitting on trucks) Charles Berkley Baughan, John A. Cain, Joseph L. Woolfolk, Marion Leake, Bill Denton, Arthur M. Badgett, and Ernest W. Denton. (LCHS)

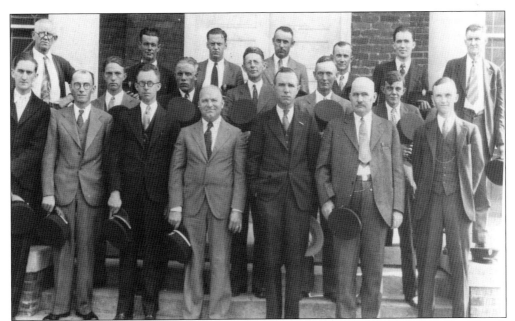

LOUISA FIRE DEPARTMENT Posing in their new caps on the steps of Louisa Baptist Church are: John Richard Maddox Jr., Elijah L. Southard, William E. Lynch, Marion W. Leake, Henry J. Woolfolk, John A. Cain, Arthur M. Badgett, Otis Rupert Thompson, Ernest W. Denton, Samuel B. Henson, John O. Rhodes Jr., Charles Berkley Baughan, Joseph L. Woolfolk, Alfred Percy Gates, Richard E. Perkins, Allen W. Flannagan, William A. Cooke, Robert Kent Woolfolk, and William L. Denton. (LCHS)

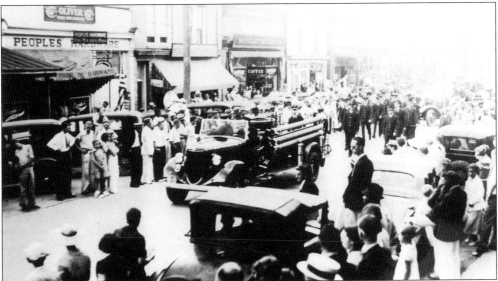

LOUISA PARADE The 1937 parade was led by the old fire engine. Looking at the north side of Main Street from left to right, we see People's Hardware and the Sunny South Store, which were both in the building that is now Affordable Furniture. The Sanitary Grocery Store (Safeway), which later became Shanks, and Madison's Grocery follow. The next building, once a cafe and then Duncan's Store, has been demolished. Ace Hardware, originally Beale's store, is the last building in the row. (Gilmer)

LOUISA PARADE A band marches past the Swartz Restaurant, which is now Nolin's Jewelry. The Atlantic and Pacific Store (A & P) was later Tolbut's Shoe Shop. The former Kent's Drug Store, now Baileys, completes the picture. (Gilmer)

LOUISA BOY SCOUTS The July parade in 1937 brought out the Louisa Boy Scouts. They are, from left to right: Allen Flannagan, John Gilmer (with the flag), Percy Gates, Lindsey Gordon, Bill Osborne, Jim McCarrick (turned), Carrol Clark, Alfred Biggerstaff (?), and Buddy Boxley (?). (Gilmer)

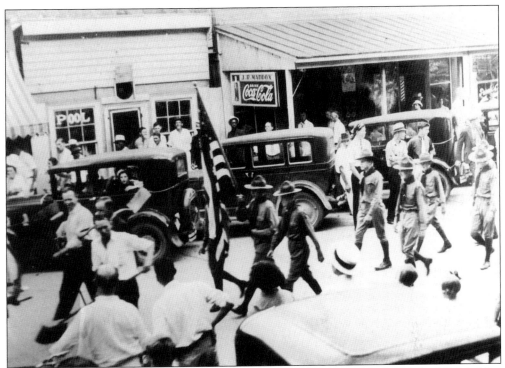

LOUISA PARADE The Louisa Boy Scouts march past the old pool hall and the J.R. Maddox Store. Notice that the cars used to park on the diagonal. (Gilmer)

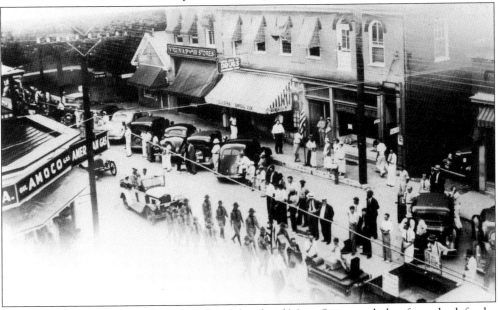

LOUISA PARADE This view over the north side of Main Street includes, from the left, the W.E. Bibb law office, Grau's 5 ¢ to 10¢ Store, Louisa Drug Store, and the Boxley Building (without its front porches). Part of Perkins and Woolfolk Department Store can also be seen. This building later housed the Louisa Department Store. It is now Wright-Loving Furniture and Appliances. (Gilmer)

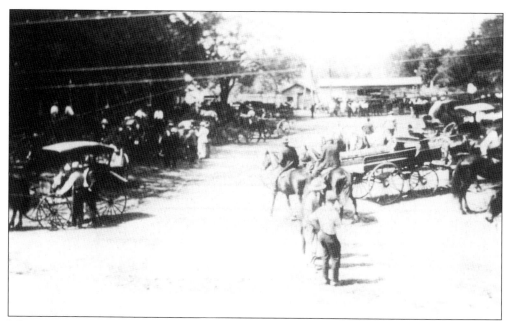

LOUISA MARCH COURT DAY The March Court Day was traditionally held on the second Monday in March, when the regular court session took place. With the first break in the winter months county residents flocked to the courthouse to barter, buy, and sell, and to socialize and find out who was still alive. This picture from 1920s shows the crowds at the juncture of Route 33 and Route 208. The Louisa Methodist Church is on the left. (LCHS)

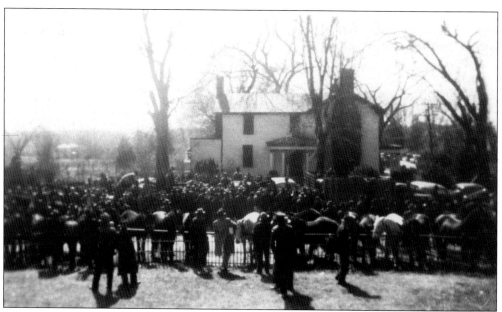

LOUISA MARCH COURT DAY Taken about twenty years later, but in the same general area as the previous photograph, this picture of March Court Day shows the same mixture of horses and people, but also includes a few cars and trucks. The Flanagan House is in the background, and what could be "Woodbourne" is in the extreme background. (LCHS)

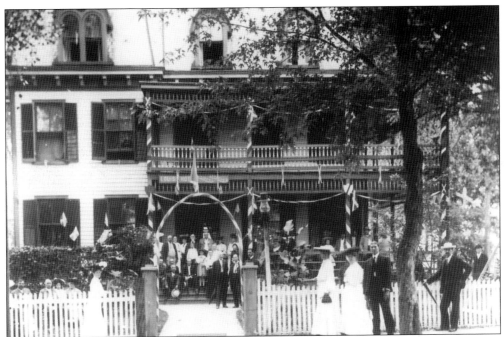

LOUISA HOTEL This crowd at the Louisa Hotel has gathered for the joint reunion of Confederate veterans from the Richmond Pickett Camp and the Louisa Camp, who were attending the dedication of the Confederate monument in 1905. The hotel was owned by Hugh Dickinson at this time.

MAIN STREET This picture, taken sometime between 1905 and 1911, looks east up Main Street in the vicinity of the courthouse. Notice the windmill on the right. The wooden sidewalks, dirt road, and plank bridges can plainly be seen. The gentleman appears to be Dr. P.P. May. This is an everyday view of Main Street with no March Court Day crowds. (LCHS)

Acknowledgments

Special thanks to members of the Louisa County Historical Society for their support with this project, and to Griswold Boxley, Carter Cooke, John Gilmer, William Kiblinger, Frances Marshall, Jimmy Talley, Chris Thomasson, and the *The Central Virginian* for keeping the past alive.

Thank you to the following for their help with identification and for their memories: Milton Atkins, Eugenia Bumpass, Greg Ferguson, Quintus Massie, Bill Pettit, Judy McGehee, Bill Porter, Enos Southard, H. Manning Woodward, and Jim Zinck.

The Office of the Clerk of the Louisa County Circuit Court and *A History of Louisa County* by Malcolm H. Harris were also important resources.

LOUISA COURTHOUSE DAR The members of the Louisa Courthouse Daughters of the American Revolution in this photograph are, from left to right: Miss Lizzie B. Francisco, Miss Kate Vaden, and Mrs. Mattie F. Winston. The Louisa Courthouse chapter of the DAR was organized in April 1935. Mrs. B.V. Boxley was the organizing regent, and the chapter had fourteen members. (CV)